THE CHANGING CONCEPT OF REALITY IN ART

by

ERWIN ROSENTHAL

Introduction by Deborah Rosenthal

A Biographical Note by Julia Rosenthal

ARCADE PUBLISHING • NEW YORK

TO KARL KUP

Acknowledgments

This book has grown out of reflections over
many years, in the course of which I have, in
lectures and publications, stated some of its
themes. "Giotto and Dante" was the subject of
a public lecture at the University of California
in 1941. I also lectured upon "Picasso, Painter
and Engraver" there and at Howard University
in Washington, D.C. in 1947. The text of that
lecture was later privately printed in an edition
of seventy five copies by Adrian Wilson, San
Francisco, for Igor Stravinsky, on the occasion
of his seventieth birthday (1952). An extract
from "The Condition of Modern Art and
Thought" appeared in "Scritti di Storia del-
l'Arte in onore di Lionello Venturi," edited by
de Luca in Rome, 1956.

Contents

Introduction

by Deborah Rosenthal

The writings of Erwin Rosenthal, who died in 1981, are virtually unknown today. Originally published in 1962 by George Wittenborn—who brought to American readers such crucial texts as Mondrian's *Plastic Art and Pure Plastic Art* and Robert Motherwell's *Dada Painters and Poets*—Rosenthal's *The Changing Concept of Reality in Art* presents readers with what amounts to a fresh, unexpected voice in a very old discussion about the nature of artistic style. Rosenthal's writing has some of the intimacy and freewheeling exploratory spirit of conversations between friends who love art. As he investigates the origin and evolution of artistic style, he moves from art to literature, from psychology to music, reflecting on the sculpture of Henry Moore, the poetry of Mallarmé, or the architecture of New York City. Rosenthal sees a tension between two competing views of the origin and evolution of artistic style; he regards the artist both as a prime mover, willing styles into being, and also as the instrument through which more general stylistic shifts are registered—shifts that reflect transformations in culture and society at large.

Rosenthal, who earned a doctorate in medieval art history at Augsburg in 1912, spent his student years near the epicenter of these debates about artistic style, many of which were taking place in Austrian and German universities and museums and in books and articles published in Vienna and Berlin. But in choosing never to pursue an academic career, he ended up standing somewhat apart from these debates as well. Instead, as his granddaughter writes in her biographical

note in this edition, he entered the family antiquarian-bookselling firm, and for the rest of his life he worked in that business while writing occasionally on art-historical subjects that interested him. *The Changing Concept of Reality in Art*, which collects some of Rosenthal's historical observations and aesthetic musings, is a meditation on the subject of abstraction and representation. The "reality" of Rosenthal's title consists of everything the artist can feel or experience or perceive, whether that reality is expressed through naturalistic forms or through forms that reject the appearance of the natural world. He invites us into the intimacy of works of art in all their permutations. Moving back and forth through the history of many arts, he reveals the contours of his mind and his personality by distilling parallelisms and polarities within artistic styles; a reader feels the varied aspects of Rosenthal's taste. As a scholar, he most often wrote about medieval art. But he was also fascinated by twentieth-century abstraction, the revolutionary art of his youth, which was still evolving in the 1940s, when he gave the occasional lectures at American universities on which some of these essays were based.

Though Rosenthal's canvas is large, he works with light touches. There are passages that home in on individual periods, artists, or works of art and crystallize ideas through an apposite quotation, a bit of formal analysis, or a summary of historical phenomena. He frames his discussion with the years 1300 and 1900. He focuses first on the pivotal figures of Giotto and Dante, who were transforming the spiritual, anti-naturalistic expression of the Middle Ages into an art that represents the world as men and women see it. Turning to 1900, he shows how Picasso and his contemporaries reversed that revolution, and restored the possibilities of an abstract

art. He takes the reader to the 1937 Paris World's Fair to look at etchings by Picasso, and on the same page mentions twelfth-century art from Catalonia; he cites contemporary Japanese art, and recent exhibitions by little-known French artists. He draws parallels between the plastic arts and music and poetry, and touches on philosophy and psychology, at one point reminding the reader of a link between Freud and Virgil. Declaring himself a humanist, he expresses his belief in "art as thought, thought as art"—perhaps deliberately echoing the title of *The History of Art as the History of Ideas* by Max Dvorak, one of the Viennese academics who had framed the great art-historical questions in Rosenthal's student days.

Rosenthal's deft sketches of some of the developments in the art of the past seven centuries outline a fundamental duality of abstraction and representation that was already familiar when he published this book. It is hard to imagine that he was not thoroughly familiar with Wilhelm Worringer's 1908 *Abstraction and Empathy*, a German dissertation published, to a very wide reception, a few years before he wrote his own. When Rosenthal in his foreword disclaims any grand dialectical frame and says he is not constructing a psychology of art, he may be thinking of Worringer's book, which is subtitled "A Contribution to the Psychology of Style." Whatever his sympathy with the touchstones of Worringer's theory, his own approach is more open and speculative. For Rosenthal, abstraction and representation are both expressions of reality, and both may be present in the imaginations of artists in all times and places. He believes that the artist's deep connection with reality, which is nothing less than the sum of his experience, fuels even the geometry, stylization, and reduction of artists who have worked in a non-naturalistic

manner throughout the ages. He says that "Contemporary art has not, any more than contemporary science, abolished reality but has opened the way to a new concept of what is 'real.'" Rosenthal would certainly agree with Paul Klee, who said that the abstract artist "makes visible" a world.

Rosenthal was, like the art historian Meyer Schapiro, a scholar of medieval art who moved in literary and artistic circles and followed the work of contemporary artists. In Rosenthal's case, in part because he was a dealer in rare manuscripts, he was accustomed to studying particular works with great care and, through his connections with composers whose papers he handled, was especially sensitive to the relationship between the creator and the creation. With Picasso, whom he calls "the most conspicuous artistic genius of our time," Rosenthal seems to agree that the work of art "must live always in the present." As Rosenthal's explorations in the art of the past bring him back again and again in these essays to the art of his own century, and to contemporary art, we are reminded of the *Blue Rider Almanac,* published in 1912, in which Wassily Kandinsky and Franz Marc juxtapose Egyptian shadow puppets and Russian folk art and other "abstraction" of earlier centuries with the abstractions of Delaunay, the music of Schoenberg and Berg and Webern, and more. Some of the very same sorts of juxtapositions stud Rosenthal's text and the illustrations to his text. In his foreword, Rosenthal writes that "the history of artistic creation is not so much one of the coming, flowering, and decaying of styles as of the ever-changing materialization of some elementary aspects of the mind."

The abstracting mind, whether medieval or modern, is perhaps what Rosenthal loves the best. His sketches of

artists including Cimabue, Redon, Picasso, Klee, Mondrian, the medieval Spanish book illuminators, and the twentieth-century American sculptor Richard Lippold hold up the abstracting mind and look at its many aspects. Stylization, reduction, and geometricization of form figure in what he has to say about abstract art in both the past and the present. But he goes beyond these rather familiar hallmarks and outlines an unconventional lineage for the twentieth century, a symbolist tendency that through metaphor adds elements of variegation, expatiation, and elaboration to his picture of abstract style and temperament. The modern mind begins not from the thing seen but from what Paul Klee called "the relativity of things seen." This relativity—the relativity of metaphor—-is what Rosenthal is referring to when he quotes Rilke saying that "The thing is not itself." For Erwin Rosenthal, there is no rejection of reality but instead a continual rediscovery of reality through art's endless transformations.

July 2012

Foreword

Historians and art lovers are used to distinguishing between ancient and modern art, although it may be difficult to say precisely where the break between the two occurs. What we call modern becomes ancient to the coming generations: in fact, styles constantly change and fluctuate. The transmutation of artistic form depends on individual decisions and cultural developments. But there are basic laws of self-expression which do not change, laws which are perpetual because they accord with the structure of the human mind and soul. The perception of the artist and the basic decisions he makes in regard to form originate in psychological determinations innate in every artist and effective throughout the centuries. In this sense, the history of artistic creation is not so much one of the coming, flowering, and decaying of styles as of the ever-changing materialization of some elementary aspects of the mind.

Thus, historical phenomena may be coordinated in such a way that the artist himself appears to represent the eternal continuity in art history. To whatever century he belongs, he follows the same basic aesthetic drive and the same psychological mechanisms. According to his own criteria and to the cultural condition into which he was born, he will take his stand in the fight for form and expression. His subject is always *reality*, and his conflict is that between the recognition of the object "as we see it" and the rejection of realistic form. Rejecting naturalistic form means a resolution to change the object subjectively in order to stress its deeper meaning. This opens

the way to supranaturalism and symbolism—as expressed through stylization, distortion, abstraction. Thus the artistic perception of every artist is limited in that the artistic form is always characterized by the tension between realism and anti-realism. There are, however, no limits to the individuality and variability of self-expression.

Approaching works of art in this way, we find that such words as "ancient" and "modern" do not express the essential meaning of art. Artists separated by centuries and countries concur in the similar way in which they decide whether to fully embrace the outer world or to overcome naturalism and depend upon ideas. Finding a similar psychological pattern in an ancient period and in our own time as well, brings bygone artistic creations close to our own desires and sufferings and makes us recognize contemporary art as an integral link in the perpetual chain of history.

My essays make no attempt to give a survey of the history of art from the psychological point of view. Rather, they seek to cast light upon specific conditions of art and thought around 1300 and around 1900. It may become clear that these two epochs mark most impressively the two basic directions in which the eternal problem of realism versus the non-objective can be solved, and that they thus epitomize with telling distinctness the fundamental conflict within artistic creation.

The specific direction of self-expression in the arts cannot be understood apart from a general psychological approach to art. That direction is a part of the general predicament of thought in any age. Therefore, in the following chapters, I try to point out how artists, musicians, writers, and especially poets, meet here and there under the same or similar cultural conditions. In Chapter I, I speak not only of Giotto but of

Dante as well. The characterization of Picasso in Chapter II draws upon music and literature. Chapter IV, dealing with the condition of modern art, tries to show its connection with the other arts—with poetry above all—with philosophy, and with modern culture in general. In other words, I try in this book to treat art as thought and thought as art.

E. R.

I

GIOTTO

AND

DANTE

In discussing the foremost poet and the foremost painter of the Middle Ages together, it is clear that it is not our intention here to present a detailed treatment of the poetry of Dante and the painting of Giotto. It would be particularly desirable to make a thorough analysis of Giotto's painting — of his contributions to the fields of formal principles and spatial relationships. Here, however, we will limit ourselves to examining his art in the light of mediaeval thought. This approach will reveal the painter's problems as an intrinsic element in the predominant cultural development of his age. Thus, the transition from two-dimensional to three-dimensional space and the growth of natural, individual form are seen as phenomena which arise out of the unfolding process of humanization. In this way, we intend to show how, at a particular moment in history, a very great poet and a very great painter are symbolic of an era and how their works have had a powerful influence upon the intellectual growth of the world. Not every epoch possesses artists who embrace the meaning of an entire period. Yet, in the year 1300, living near one another and of almost the same age, we find Dante and Giotto, whose works have become a great manifestation of mediaeval life and thought.

Giotto di Bondone and Dante Alighieri were both born in

Florence in the late thirteenth century. At this time Paris was the center of European intellectual life, and Italy had been forced to relinquish many of her most important personalities to the universities of France. About the time of the birth of both Dante and Giotto, Thomas Aquinas was lecturing before crowds of eager listeners at the Sorbonne, and his most celebrated colleague, Bonaventura, had likewise been summoned from his Italian homeland to Paris. Of these remarkable new forces in philosophy and art we shall speak later. Above all, new problems were developed which were, in turn, carried back to Italy and there occupied the most creative minds. While Dante and Giotto were growing to maturity, everywhere in Italy new currents of thought were pushing to the surface. This was the period of the flourishing and bellicose Communes, of free cities, centers of culture and independence. Tuscany rose to prominence and prosperous 13th century Florence spanned the Arno with three new bridges to cope with the increase in traffic. There was vigorous activity in politics and letters, and in the lively discussions French and Provençal were to be heard along with Italian and Latin. Elements from neighbouring lands were absorbed into the native culture, particularly the fresh ideas which were flowing in from France. What had so far been a history of art void of names had turned into a history of artists, for painters and poets now rose as tangible personalities. A considerable number of young writers gathered there and zealously occupied themselves with the creation of new literary concepts; for the first time, personal and individual experiences were cast into poetic form.

Although hardly a uniform group either artistically or politically, these young artists tended to be seriously con-

cerned with political problems. This was essentially the new element which bound the poets together; this drawing upon life itself created a new ethical basis for their realism. Their poetry was given the name *dolce stil nuovo*—the "sweet new style". This was the environment in which the young Dante grew up. In it he learned to interpret nature with much more concreteness than was known to the formalistic literature of the troubadours and the Sicilian poets. He brought the new realism to greater heights and established a new idealism.

Dante built his poetry upon the foundation which his predecessors to the twelfth and thirteenth centuries had laid, upon the Latin hymns as well as upon the profane lyric of the troubadours and the Sicilians. In the Latin poems of this period, for example, there developed a new concept of Christ: from the so-called *maiestas Domini*, a severe and majestic figure, He evolved as the bearer of mercy and forgiveness, sympathetic to the suffering of man—the type of the *Buon Pastore* or "Good Shepherd". In the lyrics devoted to the Virgin a parallel phenomenon may be observed: Mary, the mother exalted, comparable only to the glow of distant stars, came to be represented in the twelfth century with more gentle, more human qualities. She became one who walks among men, a helper in need (this was also her role in the contemporary mystery plays), praised for her sweetness and likeness unto a flower.

This transformation of attitude can be very effectively illustrated with examples from French sculpture. The representation of Christ at Chartres clearly demonstrates the trend from solemnity to benignity. The most perfect example of this new synthesis, however, is in Amiens—the so-called *Beau Dieu*. And it is the same path—the path from transcendental

and formal majesty to a Christ type which is at once human and ideal—that we have also found in literature.

There are two representations of the Virgin in the Cathedral of Notre Dame in Paris, one belonging to the twelfth century, the other to the thirteenth which, when compared, exhibit the same phenomenon. Upon looking at the first, we are impressed by its severity and rigid form. The second, superbly wrought and produced about a century later, is bound to affect the onlooker very differently. It represents another world entirely. Here a mother holds her child on her arm, as if the artist had before him a living model. Gone is the Byzantine formalism, and in its place we have the natural roundness and fullness of the human figure, the folds of her garments modelled after real folds. Yet it is not sensual, nor is it lacking in formal dignity. The artist does not concern himself greatly with personal details but produces instead a type. The most developed example of this is the Madonna at the Cathedral of Amiens, called the *Vierge Dorée* because of her radiant beauty.

This very transformation, this new sentiment, is what was meant above where reference was made to the new realism and the new idealism of Dante. When we contemplate the *Vierge Dorée*, we understand what is meant by the statement that Beatrice is both human being and angel. Even her death is mourned, in the "Vita Nuova", in a manner foreign to the chivalric and court poetry, which was only able to evince rebellion against the harshness and cruelty of Fate. But Dante gives voice to a spirit of reconciliation—and the very last word of the "Vita Nuova" is "benedictus".

While Dante, at the very beginning of the fourteenth century, was writing his greatest illustration of this principle and

this unity of vision and reality, the Divine Comedy, the drama of the world and its salvation—Giotto was completing his great cycle of frescoes in the Arena Chapel in Padua. It is now time that we turn to the painter that we may see how, in his theory and practice of art, he stood in relation to the problems of his times.

One of Giotto's greatest and most mature works, "The Holy Virgin with Saints and Angels", formerly in the Church of Ognissanti and now preserved in the Uffizi Gallery in Florence, may be significantly compared with the famous Madonna of Cimabue, which was painted in Florence when Giotto was still a young man. Although the Madonna of Cimabue, when contrasted with earlier representations, can be said to already show certain naturalistic tendencies, the predominant tone of the picture is typically mediaeval. The stage in which the figure and the throne are set lacks definiteness and is quite imaginary. Here Mary is far less a real woman than she is the solemn *Mater Dei*. Giotto, on the other hand, paints a woman of flesh and blood, and the saints and angels surrounding her appear conscious of the importance of the moment—a human relationship seems to exist between them. The setting is no longer imaginary; rather, we see real stone, Gothic patterns, and the folds of the Virgin's dress seem to be made of actual material.

Thus we may say that Giotto, in his approach to reality, represents a basically different artistic vision from that of Cimabue. In the painting of the early Middle Ages the figures rest in one plane, in almost pure two-dimensionality. Giotto, in contrast to this, has a concept of cubic form: his figures have volume, with the result that his compositions have an effect of depth, an effect which is heightened by the stage-like

construction of the buildings and landscapes behind. This sense of mass and volume, this feeling for construction in composition, was first given expression by Giotto.

Cimabue is abstract and impersonal; Giotto replaces symbolism with function and action. Abstract beauty has been supplanted by an entirely new element which we may call moral beauty.

In the light of these observations we understand the words of Dante in the Divine Comedy when, after referring to the fame of Cimabue, he wrote, "... ed ora ha Giotto il grido" — now it is Giotto's turn for fame, now his name is on everybody's lips. For us this means more than the mere fact that fame is ephemeral, for we know today that each of the two masters represents a different world and that with Giotto begins a new attitude toward art.

Is not this change in attitude the same as the difference we found between Dante and his predecessors, the same as the one we found in the development of French sculpture? As a matter of fact, the French sculptors of Chartres, Reims, Paris and Amiens were much more truly the forerunners of Giotto than the Italian painters were. Indeed, the model for Giotto's Madonna is the later Virgin of Notre Dame — although he may well never have seen it.

The liberation of sculpture from the outworn abstract forms of the Middle Ages finally began in Italy also, but considerably later. Some time after the beautiful figures of Chartres were executed, Nicola Pisano, inspired by Roman art and above all by the Roman sarcophagi, opened the way to a new realism. But it is only when we come to his celebrated son, Giovanni, that we find a synthesis similar to that of Giotto. Both were working on the same problems, though we

cannot say that Giovanni influenced Giotto. In fact, when the two artists met in Padua in 1305, we find Giovanni sculpturing a figure of Mary which shows, rather, the influence of Giotto upon him. Giovanni Pisano advances the new Gothic elements in Italian sculpture—and this by no means without a real contact with French models. Giotto, however, draws up the code for all these new elements and establishes a new order for the principles of art.

Let us compare Giotto's Christ type with that of Pietro Cavallini, a Roman painter older than Giotto and a contemporary of Cimabue. Between the Cavallini figure of Christ and the Paduan representation by Giotto there is a lapse of little more than ten years. The Christ of Giotto realizes, in fact, something which had never before been expressed in Italian painting. From Cavallini's solemn frontal rigidity Giotto finds the step to a new plasticity and creates a Christ figure which is human as well as exalted. To fully understand this development, we have but to look again at French art and see that the real forerunner of his Christ is the *Beau Dieu* of Amiens. The mouth on Cavallini's Christ face is severe and unyielding, while the mouth on Giotto's is slightly open. It is obvious that Giotto was influenced by a head such as that of a king from the Cathedral of Reims, which expresses this new tender pathos—a pathos beyond human passions. Here, too, the lips are parted and breath, a gentle sigh, seems to pass between them. The expression of both figures reflects a deep awe before the Divine and the Supernatural, so that the lips are irresistibly forced open. This was a new element which Giotto brought to Italian painting.

Were we to try to formulate this into words, could we ever find a more perfect text than this verse from the "Vita Nuova"? Speaking of Beatrice, Dante says:

25

E par che dalla sua labbia si mova
un spirito soave pien d'amore
che va dicendo a l'anima: Sospira ...

And from between her lips there seems to move
A soothing essence that is full of love,
Saying forever to the spirit, 'Sigh' ...

For the poet, Beatrice is no longer mortal—she already belongs to a higher world. The sigh forced from him when he contemplates her is a sigh of veneration.

The Joachim figures in Giotto's fresco in Padua reveal what may be called "a new psychological depth". In this fresco we find Joachim returning from his sacrifice, deep in solemn contemplation. The painting is like an illustration of Dante's words: "Così m'andava timido e pensoso", which may be freely translated: "There I walked, humble and thoughtful". In the next scene, in which the Angel bids Joachim to return to his home, we find Joachim sunk in heavy sleep. For this, too, painting before Giotto has no parallel to offer. We are familiar with many sleeping figures, above all of Joseph, who was always depicted in the "Nativity" as sleeping. But such figures had always been of a formal type, following the Byzantine iconographical canon. Only when we come to Giotto do we find a *man*, a man who has fallen asleep over the questions, the hopes and the sorrows of his inner self—reminiscent perhaps of Dante himself in Purgatory, overcome by the pictures which confront him and sinking into deep slumber.

If we compare the figure of a priest by Giotto from the Arena Chapel frescoes in Padua with Cavallini's high priest from the Roman church S. Maria in Trastevere, we can safely conclude that no fellow Italian painter helped Giotto to reach

this humanization. Rather, we must seek the source of the new synthesis in France, where the new humanity is apparent in the magnificent high priest that stands on the cathedral of Reims.

Similar sources of inspiration led both Dante and Giotto to envision a world which was both real and transcendent. We can even compare parallel figures: Dante's angels, for example, are always more severe and majestic than they are gentle and mild. "Pien di sdegno" — "disdainful" — Dante calls them, and he endows with extraordinary power. They are superior to passion. Indeed, even the smile of the angel-like Beatrice — "regalmente" — is no longer a human smile but rather an expression of celestial grace. This exclusion of conflicting elements and fusion of the subjective and objective is also very characteristic of the heavenly beings portrayed by the painter. Dante's and Giotto's angels always retain their human outlines, but they live in a state of harmony of their own. The movements of these angels as we see them, for example, in "The Ascension of Christ" are the pictorial analogy of the great silent movements of the angels of Dante.

Again, the derivation is from France. The angels at Reims contain much of the dignity later described in the poetry and painting of the two Italians.

With these thoughts in mind, it would not be too daring to speculate upon how a representation of Beatrice in Paradise would appear, were Giotto to have painted one. Surely, she could not have looked very different from an angel in the Uffizi Madonna, or from the Virgin of the Last Judgment. The notion of a realistic portrait had not yet been born: this was a post-Giotto problem. Therefore, it can safely be assumed that she would have been portrayed as Dante characterized her: earthly in form, spiritual in illumination.

Up to this point we have concerned ourselves exclusively with the representation of single figures. Since these had now won a new subjective life and personality, we might expect to find that their nature and effect as a group would have to be something entirely new. This great new element is the psychological one, the element which makes drama possible.

Whereas in the "Vita Nuova" Dante sang the praises of his beloved Beatrice, the Divine Comedy is a gigantic stage-setting for dramatic action. Hundreds and hundreds of beings are represented in their manifold destinies, and there is nothing in human life which we cannot find depicted by the powerful poet. And Giotto's task is the same: to find a new stage-setting suitable for a large number of actors. His stage, moreover, is furnished with a new space, a new depth in which the new generation of human beings acts, held together in psychological unity. Dante breaks the chains of didactic poetry, while Giotto wins independence from Byzantine iconographical rules.

To give but one example of Dante's new dramatic force, we need only consider the scene of the lovers Paolo Malatesta and Francesca da Rimini. This story of adultery, love, death and eternal suffering, by which the poet himself is so overcome that he loses consciousness and sinks to the ground, has such psychological clarity that even the modern reader is deeply and emotionally stirred.

In a like manner, Giotto steps forth to give the world a psychological interplay of individuals in a painted scene, and thereby becomes the great reformer of Christian legend. Before Giotto, group scenes had taken place in a solemn and schematic world as illustrated, for example, by Pietro Cavallini's "Death of the Virgin". In Giotto's "Mourning over

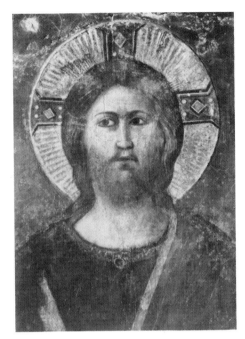

Fig. 2

Fig. 1

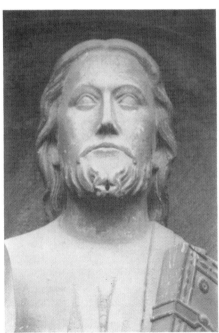

Fig. 1. Cavallini, Head of Christ. *See p. 21*
Fig. 2. Head of Christ, Amiens Cathedral.
See pp. 17, 21

Fig. 3. Head of St. Louis, Reims Cathedral. *See p. 21*
Fig. 4. Giotto, Head of Christ, Padua. *See p. 21*

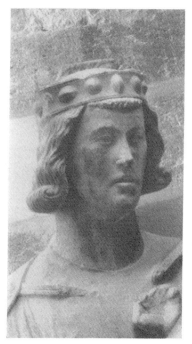

Fig. 3

Fig. 4

Fig. 5. Virgin and Child, Paris, Notre Dame. *See pp. 18, 20*
Fig. 6. Giovanni Pisano, Virgin and Child, Pisa.
See pp. 20, 21
Fig. 7. Giovanni Pisano, Virgin and Child, Padua. *See p. 21*

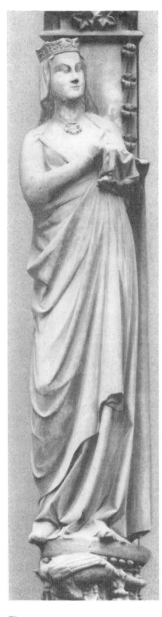

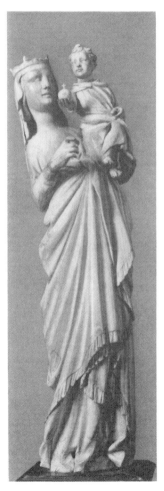

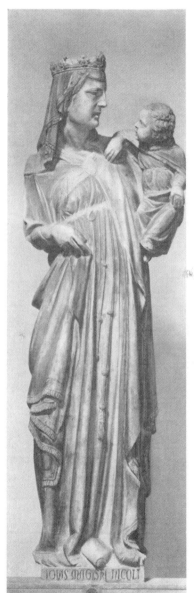

Fig. 5 Fig. 6 Fig. 7

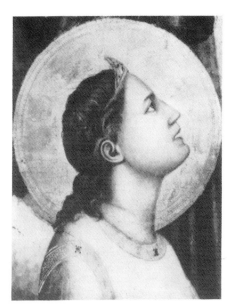

Fig. 8. Giotto, Head of an Angel
(detail). *See p. 23*
Fig. 9. Giotto, The Ascension of
Christ. *See pp. 23, 27*

Fig. 8

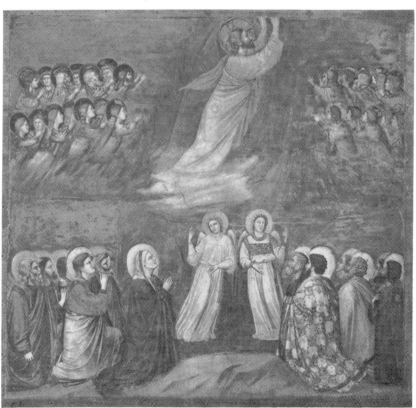

Fig. 9

Christ" we find ourselves witnesses to a vivid tragedy, and semi-consciously we become involved as fellow actors in this scene of Christian drama. The theme of mother and son is poignantly expressed: Mary, a grief-stricken woman, embraces her beloved son for the last time. The gestures of St. John and the two standing women are eternal symbols of pain and despair. Mary Magdalene, who kneels at his feet, is a figure of silent anguish. All the shades of human sorrow, from pathetic grief to the most reserved, are depicted.

The Flight into Egypt naturally offers fewer possibilities for psychological effect. Nevertheless, this is life from our life, and the human figures and background are within our realm of experience. What a profound difference between this and a scene in the Chapel of St. Sylvester, painted in Rome about 1250, where Constantinus is shown conducting the Pope to Rome! Although the composition is very similar, the figures in the earlier representation are placed all on the same plane, whereas Giotto utilizes several overlapping planes in space. Here, the contrast is between a mere rhythmic alignment of figures and the action of human beings in the real world.

Even when two figures stand facing each other, we perceive dramatic action and psychological bearing. Giotto's "Visit of Mary and Elizabeth" is a wonderful example of this, and only at Chartres in France do we find anything comparable before Giotto.

Emotional relationship is equally apparent in the heads of Christ and Judas painted by Giotto at Padua. The same subject by a Roman master in Assisi was completed only about ten years before Giotto. But, in spite of the expressiveness of the head of Christ and of the profile of Judas, there is no emo-

tional link between the two figures. Looking at the two heads painted by Giotto, one is struck by the new psychological emphasis. The whole drama of the betrayal of Christ has been put into the mutual gaze of the two. We perceive at once the treachery which is written on one face and the suffering and majestic forbearance which emanates from the other.

And so it is that the art of Giotto and Dante is true — true to nature, and religious in the deepest sense. The numerous individual destinies are examples of a single Divine Providence and Order. Each has its definite place in the infinite and measureless operation of Divine Rule. For Dante, the one great and all-pervading principle is that of *amore*, and his immortal poem ends with these words:

> *l'Amor che muove il sole e l'altre stelle ...*
> Love that moves the sun and the other stars ...

Love, to Dante, is the manifestation of the principle of Divine Order. God is like unto Love. Here it is clear that the source of Dante's ethics was Thomas Aquinas who, half a century before Dante, propounded this unity of God and goodness *(bonitas)*. Scholastic aesthetics also find their fulfilment in Dante. Bonaventura set up the law that artistic vision is God-inspired. The vision is by no means conceived solely from the object, from nature and the model — rather, it depends upon the inner picture which the artist forms in his soul. This vision is possible only as the result of Divine Grace, *mediante Deo*. Dante adopts this principle and puts it into poetic form:

> *Ciò che non more e ciò che può morire*
> *non è se non splendor di quella idea*
> *che partorisce, amando, il nostro sire.*

> That which dieth not, and that which can die,
> is naught save the re-glow of that Idea
> which our Sire, in loving, doth beget.

Christ himself gives inspiration to the artist's imagination, which, alas, can never reach the final summit:

> *Ma or convien che il mio seguir desista*
> *Più dietro a sua bellezza, poetando*
> *Come all'ultimo suo ciascun artista.*

> But now needs must my tracking cease
> from following her beauty further forth in poesy
> as at this utmost reach must every artist.

With this tragic confession, Dante becomes the first poet to lament the discord within his own personality. His vision is always as religious as it is poetic. Art, as he expressed it, is the "grand-daughter of God". He wandered through the cosmic order and lived it as a poem.

And Giotto, while he is carrying out a complete reorganization of Italian art, stands obedient to the same law. He makes a revolutionary advance into the realm of reality, yet he can only see the world and its phenomena as Dante did: as a reflection of that idea which is nothing less than *il nostro sire*, God Himself. The painter's vision is bound to the Absolute, as is that of the poet.

This union of reality and super-reality is perfectly expressed in a picture like the "Ascension of Christ". The figure of Christ is not placed as the geometrical center of a rigid symmetrical grouping—yet everything gravitates to this focus of dramatic action. This is effectively attained because the sympathy of each individual figure is directed toward God. He is in all, and all are in Him.

Dante and Giotto stand between two ages. The struggles and disputes which filled the two centuries preceding them may be epitomized in the words of St. Paul: "Littera mortificat, gratia vivificat"—the letter mortifies, while Divine Grace gives life. There was already a very strong desire to get away from the rigidity of the written word and to advance in the direction of a more living practice of religion. Heretics and mystics had long been undermining the position of the defenders of the severe dogma. If the strong cleavage within the Church could still be prevented, Thomas Aquinas was the man to do it and Dante and Giotto as artists shared in the work of reconciliation, the attempt to balance the overly sharp contrasts between the other world and this. What an ideal moment—but it was destined to be brief. History knows no constancy, and the strife between faith and knowledge soon began anew. In contrast to Thomas, the great English philosopher Roger Bacon made a severe separation between science and religion; Petrarch's sonnets illustrated an individual life which was no longer attached to a divine system as Dante's world had been; and a hundred years after Giotto, Florentine artists mixed art with the problems of the exact sciences.

Giotto's historical significance is clearly reflected in these new spiritual and artistic attitudes. It took the artists who followed him almost a century to absorb his art completely and to infuse it with new concepts of space and form. Gradually, naturalism and individualism came to supersede generalization and stylization. Giotto's treatment of space, illusionistic and imaginary alike, was no longer acceptable to a generation which leaned more and more to realistic representation. Scientifically constructed Euclidean space became the natural surroundings in which the new figures were set.

Giotto and Dante

The work of the sculptor Lorenzo Ghiberti is typical of this recognition of the new laws of optics and statics. Yet Giotto's pathos still lingers on in Ghiberti's earlier statues. And although these new principles of art grew up in a different cultural environment, it was Giotto who had paved the way; it was he who had prepared for the triumph of individualism and energetically abandoned the two-dimensionality which had prevailed since the decline of Roman art.

Many changes in the approach to life and art occurred during the following centuries, but the solutions which were achieved represented new attempts to exchange and modify the problems to which Dante and Giotto had given an unshakable foundation. Spatial relations, dramatic expression and psychological approach remained the chief problems of painting throughout the centuries until Cézanne. The psychological problems raised by Dante, the creator of modern Italian, have remained active up to the present day: clear traces of tragic conflicts such as the Paolo and Francesca episode are to be found in Shakespeare, in Racine's psychological masterpieces and in dramatic works of modern times.

The problem of faith and knowledge has never died; it is ours today—only we have a different terminology. The discord between real and sur-real, between the rational and the irrational, is always present. This discord is in modern history, art and psychology—and each individual will find it within himself.

Thus do Dante and Giotto at once embrace and sum up within themselves the wisdom of bygone centuries and point the way to centuries to come. They are not distant figures —they are very close to us. We cannot approach them without becoming aware of their eternal human qualities.

II

PICASSO

PAINTER
AND ENGRAVER

The impact of Pablo Picasso, who has continually surprised us by his productiveness and variety of style through many a decade of art, is still difficult to evaluate with exactness. Some of this difficulty may be laid to the fact that many of his major works have not yet found their way to the greater part of the public, although they are of paramount importance to anyone desiring a complete understanding of Picasso's huge *oeuvre*. I speak of Picasso, the engraver, and primarily of Picasso, the illustrator of books. The volumes that contain sets of his etchings are published in very limited editions and are kept secure in the print rooms of public libraries and in private collections. This graphic output cannot be considered a sideline, for it essentially accompanies the work of the painter and in many ways reveals new aspects of his art. Two elements give the painter's engravings a character independent of his painting: first, by being forced to utilize different technical media the artist may find expressions which are different from those he used in his painting; secondly, drawing, etching, and cutting on a block are occupations of a very intimate character and the painter, whom one might ordinarily compare to a playwright sensing contact with his public, becomes more comparable to a lyric poet having a monologue with himself.

Let us approach this intimate work of Picasso by glancing at three of his etchings: an early rendering of the *Les Pauvres*

(1905), an illustration for the *Saint Matorel* of Max Jacob, published in 1910, and an etching for the *Tauromaquia*, produced in 1929. It is obvious that the tension between the representationalism of the early work and the ultra-abstract work of 1910 is enormous. Furthermore, there seems to be no transition from the latter representation to the neo-classicism of the 1929 etching. Therefore, in order to prepare ourselves for a consideration of Picasso's graphic work, we had best begin by first investigating the general characteristics of his background and then try to complete the picture by presenting some of the features peculiar only to his graphic production.

The first etching in 1905, realistically portraying a poor family, indicates that the twenty-four year old Picasso was still under the influence of impressionism, and was driven by a strong social conscience. Considering next the abstract etching of 1910, one is tempted to accept the conclusion that Picasso had revolutionized modern art within a few years. Undoubtedly these were some of the most decisive and revolutionary years of his life. But the situation we face is a much more complex one. The change undergone by Picasso was also the destiny of others of his contemporaries, and the abstract art of 1910 certainly did not emerge from impressionism like Athena out of the head of Zeus.

As early as the 1880's, a countercurrent to pure impressionism was beginning to make itself felt. At the height of the impressionistic period there were already new elements arising in the persons of Van Gogh, whose passion and colour symbolism led to religious expression; Rousseau, who introduced a type of primitive simplicity; and a mystic movement in the work of a visionary, Odilon Redon.

The most significant opposition was offered by Cézanne.

Remarkably enough, the hand which first began to actually reduce and simplify form to its basic geometric and cubic fundamentals was that of an artist who still belonged to the early generation of impressionists. In dismissing "scientific perspective" and in the deliberate use of distortion, Cézanne was attacking hitherto sacred artistic conceptions.

With the supplanting of impressionism by Cézanne's new concepts of order and construction, another revolt propagating the absolute freedom of inner expression had been instigated against impressionistic realism. It was in the nineties that Gustave Moreau, certainly no revolutionary, taught that "Nature is merely an opportunity for the artist to express himself. Art is the intense pursuit of the expression of the inner feelings through plastic means alone." Among his pupils was Georges Rouault, for whom the teacher's words must have been a powerful challenge to create a new expressionistic dogma whose devastating effect on impressionism Moreau could never have anticipated. Here again is evidence of the almost thirty years of development instrumental in undermining naturalism and impressionism.

While stressing the historic aspects of this period, we can easily destroy another prejudice, the stereotype that Picasso and his contemporaries turned to abstraction through a purely intellectual process and by following the dogmatic manifestos and suggestions of art critics.

Can we seriously consider that they "have voluntarily submitted their sensibility to fixed rules," as Charles Terrasse has stated? It is true that the subject was widely discussed, not only among the artists themselves, but also in the company of theorists and critics. There is no artistic creation without rational analysis, and often in history the artist, critic, and

theorist were one and the same person. Unquestionably these burning problems of the day were discussed by Picasso and the critics, just as Bernini discussed the problems of Baroque art with the distinguished critic, Monsieur de Chantelou. However, Bernini's art was not the consequence either of those discussions or of the aesthetic rules of the Roman Academy, and Picasso never had to rely on the guidance of Guillaume Apollinaire or others of his literary circle.

For those who knew Paris around 1910, the revolutionary acts of artists like Picasso were not considered the products of intellectual gymnastics of the literati, but were recognized as the result of a profound crisis in the arts. The time was past when one could find seventeenth century Dutch pictures used as models for the painting of impressionistic and atmospheric elements. The new generation decorated its studios with primitive sculptures or Romanesque and early Gothic statues and collected African masks. The shift from "impressionism" to "expressionism" was a reality. Although Renoir, Monet and Degas were still alive, a new generation had established completely different concepts of art. Cézanne's research in pure plastic values had given birth to cubism.

After his Blue Period, Picasso entered the stage critics sometimes refer to as Picasso's Barbaric Period. The traces of this manner were left, not in his etchings, but in several of his woodcuts, some of which are directly related to the most important painting of this time, *Les Demoiselles d'Avignon* (1907). As a matter of fact, primitive forms, in particular pre-Spanish Iberian sculptures and African models, were a marked source of influence on the art of that period. However, we are primarily interested in examining the specific inspiration Picasso derived from these influences. Naturally, it was not

the same in all cases. Matisse, for instance, was impressed by their linear beauty, which he felt comparable to Egyptian art. To Picasso, Iberian sources brought the mythological and ritualistic elements characteristic of exotic art. The solemn, ceremonial flavor of these representations was instrumental in creating a deeply emotional style, from whose expressiveness strong distortion and abstraction were evolved.

In 1908, Picasso began his first attempts to overcome emotionalism and in so doing he leaned toward a purely constructive art, toward cubism. These cubistic pictures and etchings are clearly the final consequence of Cézanne's experiments with the fundamentals of cubic form. The canvasses produced around 1910, as well as the etchings for *Saint Matorel*, are an accumulation of single geometrical and semi-geometrical compartments in which the contact with the visual form has lost all importance. In *Le Siège de Jérusalem* of 1913–14, this contact is completely non-existent.

The question of whether or not Picasso was the first artist to turn to complete abstraction has been discussed. This type of inquiry is as fruitless as the old question of whether Rembrandt discovered chiaroscuro painting. As we have pointed out, it was a deep, fertile soil which produced and nourished the roots of Picasso's art; similarly the ground was prepared for the effects of light used by Rembrandt. What matters is who first makes a new principle a powerful instrument and thereby becomes its leading exponent.

It would be appropriate now to analyze the positive significance of cubism, but in so doing we would be exceeding the bounds of this essay. It is a very complex chapter and perhaps it would be premature to reach definite conclusions. Cubism, and in a wider sense, abstractionism, has profound sociological

and metaphysical implications. For the first time since the Middle Ages, art has become anti-realistic. This may well be indicative of a new spiritual and social orientation of the world. Perhaps it is a widespread search for the Absolute. At any rate, during the period of the last forty years, abstractionism has spread throughout the world as an exalted language of art. For the moment it may be a secret language, understandable only to the "initiated", yet we cannot deny its universal significance.

When Picasso brought home the first cubistic pictures from the Spanish village of Gozols, he was, of course, conscious only of the discovery of a new reality. In his artistic imagination this reality took the form of abstract patterns. The ultimate harmony of such representations was the result of his subjective decision to arrange the geometric and plastic elements in a purely abstract order, an order *sui generis*.

Similar tendencies are prevalent in modern literature and music. In reference to literature we do not include dadaism, a contrivance, which in attempting to discard traditional form, failed to create a genuinely new poetry. Rather do we point to such great writers as Jean Giraudoux and James Joyce. In Giraudoux's plays and novels previous literary elements of composition and structure are suppressed, including the element of consecutive time. Although his characters are real people, in another perspective they are marionettes built of shimmering glass, performing in a timeless world of phantoms. Who can deny that this is a world of new beauty and that our individual emotions are strikingly mirrored on this fascinating visionary stage?

Giraudoux's new approach to literature, however, is a chivalrous joust compared to James Joyce's violent and

radical abolition of literary forms and inherited language. *Ulysses* was written between 1914 and 1921, exactly within the period of Picasso's strongest opposition to any form of naturalistic and imitative art.

Radical changes of structure and reaction against sentimentality are characteristic of the work of Gertrude Stein, James Joyce and other contemporary writers, and are also present in the music of Stravinsky and his followers. In 1911, the year Picasso's etchings for *Saint Matorel* were published, Igor Stravinsky's *Petrouchka* had its initial performance. Harmony was subordinated and a new musical structure based on rhythm was introduced. In 1913, while Picasso was developing the cubistic etchings of *Le Siège de Jérusalem*, Paris heard Stravinsky's *Sacre du Printemps*. The loosened tonality of *Petrouchka* was now completely shattered. It is no wonder that it was greeted with indignation by a shocked audience, to whom the unusual rhythms and dissonances seemed utterly brutal. This same indignation was prevalent at the sight of the purely abstract illustrations for *Le Siège de Jérusalem*. As in Stravinsky's constructive music, constructiveness in painting was no longer capable of stressing sentimental values or social and moral implications. These accents, typical of Picasso's Blue Period, and such etchings as *Les Pauvres* and *Le Repas Frugal* were, of course, obliterated as soon as the continuity of space and elements of natural form ceased to exist.

The struggle in art and music, symbolized in the figures of Picasso and Stravinsky, may be called the aspiration toward the Absolute. Picasso's cubism and Stravinsky's Russian Barbarism were directed against obsolete concepts, at the same time they prepared the way for a new artistic endeavour.

It may not be mere coincidence that both Picasso and Stra-

vinsky turned to a neo-classic ideal around 1920. Two etchings of 1917 and 1918, considered together, are a remarkable example of the emergence of Picasso's imagination from cubism. Each plate is an etching of the figure of a harlequin. One is almost unrecognizable within the network of geometrical pattern; the other reveals a new representational style. In 1918 Stravinsky and Picasso began to work on the ballet *Pulcinella*, which was first performed in May of 1920. The composer, now attracted by one of the 18th century originators of classic music in Italy, called it a ballet based on music by Pergolese in a modern setting. Many of Picasso's sketches for the costumes and scenery are beautiful outline drawings of classical character. At the same time this attitude is stressed in his paintings such as that of Madame Picasso, and in the first neo-classic illustrations, the *Cravates de Chanvre* etchings of 1922.

The highest stylization of Stravinsky's neo-classic stage was reached in the music for *Oedipus Rex* (1926–1927). It is a remarkable coincidence that Picasso's drawings and etchings done in the same period are the mature examples of his neo-classicism. In setting to music Cocteau's text of the antique tragedy, Stravinsky parallels Picasso, who several years later produced the illustrations to the antique subject of Ovid's *Métamorphoses*.

The drawings for the *Métamorphoses* are the peak of Picasso's neo-classic development. The figurative compositions, portraits and animal representations are described with contours of which he alone could be the master. This profound devotion to classic beauty, expressed clearly in these engravings, contains more elements of Greek vase painting than the work of any other modern artist.

Within this period of classic emphasis, a new phase of abstractionism makes its appearance. These representations are no longer composed by purely geometric methods, however. The point of origin is natural form, but a powerful imagination transforms the illusion of reality into a vision of abstract patterns. In the field of engraving, the illustrations to Balzac's *Le Chef d'Oeuvre Inconnu* (1931) are striking proof that Picasso now has need for both neo-classic and abstract art and is able, without conflict, to exhibit them side by side.

The theme of the Painter and the Model occupied Picasso during 1927 and 1928. Here the mature development of his classicism is revealed; his clear, sharp line, uniform throughout, becomes a faithful companion to the form. But his classic solution did not prevent him from presenting the same scene so strongly disassociated from the realistic form that it takes on the appearance of a pure pattern. The justification for the latter interpretation can be taken from an excerpt of Christian Zervos' *Conversation with Picasso* in which Picasso said: "Do you think that it concerns me that a particular picture of mine represents two people? Though these two people once existed for me, they exist no longer. The 'vision' of them gave me preliminary emotion; then little by little their actual presences became blurred; they developed into a fiction and then disappeared altogether, or rather they were transformed into all kinds of problems. They are no longer two people, you see, but forms and colors: forms and colors that have taken on, meanwhile, the idea of two people and preserve the vibration of their life." (The English translation is from Mr. Barr's book, *Picasso, Fifty Years of His Art*, published by the Museum of Modern Art, New York, 1946.)

In considering the seeming paradox of Picasso, the passionate crusader of abstract art, and Picasso, the protagonist of the salient force and charm of classic line, it is important to examine him in the light of his Spanish heritage. Although he has never denied the Spaniard in him, we have, nevertheless, become accustomed to associating Picasso with the great upheaval in art which occurred in Paris during the first decade of our century. In spite of Picasso's steadily increasing incorporation with the entity of French art, there are remarkable Spanish features in his art. We shall not dwell here on certain obvious influences, such as that of El Greco, which were present in Picasso's early work. The Spanish elements are more obvious when we strike a comparison with the essential qualities expressed by Francisco Goya, the painter and, like Picasso, the engraver.

The work of both Picasso and Goya is impregnated with the recognition of beauty, charm and elegance, as well as with their opposite extremes, ugliness and cruelty. It is this typically Spanish characteristic that is responsible for both men's application of the ambivalence of noble form and cold distortion; to experience the world in its aspects of beauty and its most terrible contrasts of destitution and bestiality.

One of Goya's etchings for the *Caprichos* portrays a man slumped over his desk asleep, while a swarm of bats and owls circle about him. The figure is undoubtedly the artist himself. Goya's comment was: "The imagination uncurbed by Reason gives birth to monstrosities." The artist, assailed by demons of the imagination, must bring them to an objective focus in order to dispel them. Goya is a Spaniard: the ecstasy of pain is traditional in his country, where religious piety and bloodshed, martyrdom and gaiety, beauty and brutal deformation are in-

separable throughout its history. Goya is the first Spaniard who did not symbolize the pathos and tragedy of his people through the use of black shadows or distorted saints; the Golgotha of humanity is in him and in his environment, in the streets and in the houses. The Napoleonic War, with its resultant heroism and cynicism, was performed before his eyes.

It may be said that Goya's fight against the tortured visions of his imagination is comparable to the continuous struggle of his Spanish follower, Picasso: Dream wrestling with Reason, Chaos pitted against Order. To be sure, in the 1920's there are pictures by Picasso that reflect the clarity of classical attitude, but soon, as if the fearful phantoms had renewed their attacks, his work becomes the representation of a world of distortion continuing in this vein up to the forties. Although contours still play a dominant role in Picasso's paintings, they are now utilized as the thick and powerful outlines of strange, emotional forms. *Seated Woman*, painted only a year after the 1931 publication of the *Métamorphoses*, fully demonstrates the emotional qualities of the new semi-abstract style. The two-eyed profile and the three-eyed portrait originated in cubism as experiments in creating a synopsis of physical features. Now the repetition of the eyes underlines the emotionalism of the work.

It becomes more evident in the later paintings that Picasso's simultaneity of vision is used to express contrasts which also played a dominant role in the world of Goya. Let us turn to his representations of young women: his imagination pictured them dragged into the depths of misery and brutality; their lovers died in their arms; they battled, desperate and hopeless, against men and monsters. Similarly in the later portraits of

6

Picasso, horror and death are ever present behind the figures of the living. Noble form can be disfigured in an instant by lurking mischief, distorting its features into frightening grimaces.

In the Middle Ages it was customary to erect the statue of a beautiful, elegantly dressed woman at the entrance of a cathedral with the figure of a mundane seducer opposite her. Upon circling the man's statue, however, one would find that his back was covered with crawling vermin. The medieval artist wished to show two aspects of the figure: the youth and beauty of the man, as well as the degradation and corruption symbolized by the vermin, which is destructive to his body and soul. Picasso has reached this point of complete summary, presenting in one visionary symbol both form and deformation, nature and its destructiveness.

Always foremost in the Spanish mind, the rapidity of change from life to sudden, bloody death is symbolized in the national game, the bull fight. This spectacle, most vividly expressed by Francisco Goya, has left recognizable marks on the work of Picasso. More than just a vestige of memory, the bull fight is instrumental in giving him one of his most important subjects: the deeply symbolical significance contained in the death struggle of bull and horse. In the Middle Ages two fighting animals symbolized the struggle between Good and Evil: Picasso's bull is the power that brutally destroys noble beauty, the horse. In the etchings of *Tauromaquia*, 1929, as elsewhere, the tortured, convulsive head is a gripping expression of the death throes of the animal. Again, in the scene taken from the Balzac illustrations, the horse is helplessly cornered, waiting for the bull's horn to deliver the final, mortal blow. Although Picasso does not necessarily characterize the

bull as Evil, he is obsessed with these tremendous forces of life which, at any given moment, can destroy the weaker and less protected.

The French-Spanish War of 1800 was responsible for Goya's set of etchings, *Desastros de la Guerra*. Picasso, stirred by the appalling bloodshed of the Spanish Civil War, etched a similar set entitled *Sueño y Mentira de Franco*. Indeed, in Goya's words, these are true *sueños de la razon*, veritable nightmares that attack in the absence of reason.

The greatest contribution to the theme of the Civil War, however, was offered by Picasso's *Guernica* mural. Never before had modern art produced such incisive symbols of the destruction of human life. The presence of the bull here is no coincidence of the imagination. That he was meant to play an even more momentous role can be borne out by reference to one of the first versions of the mural, where his firm, remote coldness is clearly a counterpart to the horse, the victim of brutal annihilation, who falls in the midst of dying human beings.

Both Picasso's *Guernica* and Goya's *Desastros* constitute a bitter denouncement of inhumanity. In contrast to Goya, Picasso approached the problem of the *Guernica* mural with the full equipment of the modern abstract artist. The means by which he captured the effect of a world of debris, fear and suffering cannot be compared with Goya's stark realism, but both were working toward the same goal. Goya's commentaries on the *Caprichos* assert his desire to relate only the truth; similarly Picasso's great Guernica mural and the *Sueño y Mentira de Franco* etchings are documents of truth.

Despite the incoherence and the convulsion present in the *Guernica* mural, it is important to note the elements of linear

beauty involved. These outlines are drawn with all the mastery of the classic draftsman. In regarding these elements of linear beauty, profound expressionism and abstractionism as a whole, it is possible to see a bridge to early medieval Spanish art. These same characteristics appear in the numerous colored drawings of the Spanish Apocalypse manuscripts from about 1000 A.D. The Spanish people, with their profoundly mystic nature, developed with unequalled thoroughness a wide array of illustrations for St. John's *Book of the Revelation of Christ*. These illustrations reveal the same tendency to flatten bodies, the use of symbols, abstraction and overstatement of expression, the same austerity and beauty of outline. There is a certain relationship between a representation depicting the destruction of mankind by the Great Flood in one of the "Beatus" manuscripts of the 11th century and Picasso's *Guernica* mural. There is, for example, a surprising similarity between the dead man's head in the manuscript and the decapitated head in the *Guernica* mural.

The figure of the beggar, Lazarus, from a 12th century Catalonian fresco in the Church of San Clément de Tahull, showing an indebtedness to a new emotionalism, comes close to modern concepts. The seven-eyed animal from the same series of paintings may also indicate how deeply Picasso's roots are imbedded in the artistic traditions of his homeland. Finally, a 12th century Spanish bookpainting, an illustration of the "Beatus"—an Apocalypse manuscript—can be related to the modern Spaniard's style, that is, to his means of expression and abstraction.

Visitors at the World's Fair in Paris in 1937 could stroll from the exhibition of the *Guernica* mural to the Trocadero Museum, where an imposing selection of modern French

illustrated books was displayed. In one of the showcases the publisher Ambroise Vollard was exhibiting a few proof sheets etched by Pablo Picasso from Buffon's *Histoire Naturelle*. It was astonishing to note the striking contrast between these etchings and the *Guernica* mural. It is even more surprising today when we see the completed set of the thirty-one aquatints. This remarkable set marks the strongest turn to representationalism ever reached by Picasso. No such divergence from abstraction or neo-classicism can be found in his paintings. If we did not have this very important set of Buffon etchings, we would never have seen the mature Picasso as an artist who so clearly describes nature. Perhaps the task as such could hardly provide another solution. In fact, we can observe a similar solution in his portraits of such personages as Stravinsky, Valéry, Breton, and his publisher, Vollard, drawn during his abstract periods. These deviations were isolated cases, whereas the thirty-one Buffon illustrations are the most complete achievement of a new, mature, representational style. The picture of each animal is a powerful expression of its individual character.

The rendering of the ostrich not only exhibits the new brilliant aquatint technique of black and white accents, but also shows Picasso's ability to charge the form with dynamic energy. The bull is presented in action as a symbol of assertive male force. In many of the etchings the artist's imaginativeness captures the essential features of nature with the greatest economy of suggestion, so that the universal aspect originates from the use of only a few contours and very elementary forms. At these moments some of the drawings are reminiscent of Asiatic representations of flora and fauna. The deer conveys the impressions of Chinese and Persian painting. The

portrayal of the pigeon, interpreted with grace of line and delicacy of tone, has the Oriental touch of carefully rationed brush strokes.

Although it is possible that Picasso experienced a certain sense of rejuvenation in the return to naturalism, he has left this concept, as well as that of neo-classicism. A 1938 etching, an illustration for the poems, *L'Indicatif Présent* is surprising by virtue of its remoteness from any human form. This seated figure only indicates inhuman mechanization and abstraction. The paintings in the period from 1938 to the middle forties are devoted to the new abstractions typified by the 1938 etching, and are devoid of any trace of his late classic style. To be sure, his illustrations for a group of sonnets by Afat, printed in 1940, strongly hint that his classicism can never be totally suppressed. Nevertheless, the graceful rhythms of his neo-classicism are no more, and the classical contours outline distorted and disfigured forms.

If we interpret the works of Picasso from the point of documentary value, we can say that the tremendous unrest of the past fifty years comes to a focus in the range of his art. His great conceptual visualization reflects the change and crisis of science, music, literature and above all, the transformation of social structure. But is he the prophet of his epoch or its product? Recently Lewis Mumford stated: "Picasso's paintings have given a truer image of the world we live in than the so-called documentary realists, who show only what the most superficial eye sees." Yet one must not be too hasty in interpreting the chaotic world represented in Picasso's work as indicative of decadence and collapse. It is too soon for us to judge our cultural position, and perhaps later observers will see fit to characterize us as other than a world of

dissolution and disintegration. At any rate, in judging Picasso's work as a revelation of creative art, it can more readily be called heroic than decadent.

Even if we recognize a reflection of the world's cataclysm in Picasso's work done during the Second World War, we should be aware that he did not create concepts which were not present previously in his art. It is only his symbols that have been enhanced by a greater expressiveness. Picasso shows no signs of dissipating the passion and dynamic energy that has permeated his whole artistic career.

The seeds of this struggle to grasp life and form through the medium of several, sometimes contrary, means of expression were present in him from his youth; and here we come to the last secret of his art. Although we have to distinguish between several periods in order to get a more lucid conception of his work, Picasso himself objects to his several manners being considered in the light of evolution. As a matter of fact, his late emotional style, the synthesis of form and deformation, is found as early as 1907 in the *Demoiselles d'Avignon*. His classicism was introduced long before his brush and etching needle brought it to full realization. In the early drawings of 1902 and 1903, the graceful outlines betray his love for linear beauty. Paintings of 1905 — for example, the *Boy Leading a Horse* — are indicative of his innate relationship to classic art. The canvas *La Toilette* of the same year has a definite Roman-Hellenistic touch. The classicism of Madame Picasso's portrait, done in 1919, is merely a new stress of this understanding of classic clarity which has always pervaded his work. In his graphic *oeuvre* this trend is disclosed in the 1905 etchings *The Watering Place* and the *Harlequin's Family*. It is therefore obvious that the numerous etchings of the twenties and the

Ovid illustrations are not a new revelation of classic ideals; they signify rather the full development of this inherent ideal.

Thus we are able to see, through the consideration of Picasso's graphic art, one more proof that he has not leaped from one style to another. During the time when his efforts to substitute dynamic expression for stability of form were most intense, he could create harmonious contours with his etching needle. In the midst of the years of the Spanish Civil War and the Second World War, when his semi-abstract art was flourishing, he produced the powerful representationalism of the animal etchings. Therefore, it is always the same ego which spans the different modes of expression and forces his vision into an imagery of rational contours or emotional forms and colors. This is Picasso's fate, his mission; this is his "actual drama".

The psychologist may call this continuous battle and continuous fluctuation a conflict between the artist's rational forces and his own subconscious opponent. Picasso himself sees in it the particular character of his nature and simply states: "One cannot go against nature."

Yet his art has been, and still is, considered kaleidoscopic and shocking by many who are even sceptical of his sincere obedience to the dictates of his conscience. It was one of the most revolutionary and most bitterly attacked composers of our time, Arnold Schoenberg, who, in self defense, wrote the modest words which speak for Picasso as well as for every great artist:

"I am the slave of an internal power stronger than my education. It compels me to obey a conception which, in-born, has greater power over me than even any elemental artistic formation."

Fig. 11. Picasso, Ovide, "Les Métamorphoses". *See p. 38*

Fig. 10. Picasso, Jacob, "Saint Matorel". *See pp. 32, 35, 37*

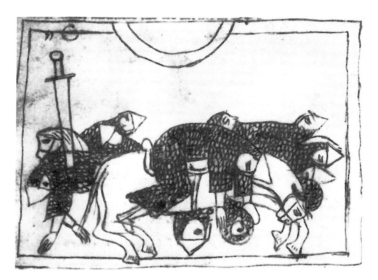

Fig. 12

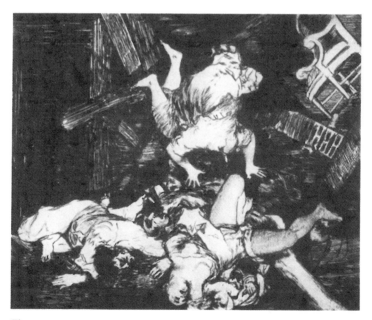

Fig. 13

Fig. 14. Picasso, "Sueño y Mentira de Franco". *See p. 43*

Fig. 12. "Dying Horsemen", Apocalypse, Spanish, 12th century. *See p. 44*
Fig. 13. Goya, The "Desastres de la Guerra". *See p. 43*

Fig. 15. Picasso, Buffon, "Histoire Naturelle". *See p. 45*

Fig. 16. Picasso, Afat, "Sonnets". *See p. 46*

III

GIOTTO

AND

PICASSO

It may seem surprising to find the first chapter, on Giotto, followed immediately by one on Picasso. Yet to the thoughtful reader it will be obvious that the method applied in both articles is the same: It is an attempt to understand the artist as an instrument of his period, as an intrinsic element in the general development of thought and culture.

There is, however, a particular historical reason for considering Giotto and Picasso from a single viewpoint. Each one marks an end and a beginning. In Giotto, we see the close of a great age of symbolism and the opening of a way toward the realistic art of the Renaissance. Picasso's mission is leading in a contrary direction, away from representationalism and toward a new era of abstraction.

During the centuries preceding the appearance of Giotto, art had concentrated upon the expression of spiritual content rather than upon natural realistic form. The great Italian painter was born into a world of solemn abstraction. The first inroads into its austere concepts had been made by the French sculptors of the 13th century, and Giotto was their immediate successor in Italy. It was a long process which had already begun in the 12th century, and it represented a reaction against a highly dogmatic spirit. The consequences of this reaction made themselves felt in poetry as well as in the visual arts.

This humanizing element, which embodies a new and profound interest in nature and natural form, is certainly not a purely individualistic tendency such as we know of in the Renaissance period, for mediaeval transcendentalism had not yet ended. There was, however, an obliteration of the sharp contrast of earthly world and spiritual life. The experiences and emotions of a still solemn world grew out of human relationships. It is this new naturalism, as well as a new spirituality, that characterizes the pathos of Giotto's art. Liturgical poetry and Franciscan literature had reached a similar synthesis about 1300, and Dante's Divine Comedy marked the peak of this philosophy which bound the freed individual being to a transcendent world.

Gradually but inevitably, stylization and two-dimensionality were relinquished; a new representationalism arose which was one day to recognize the rediscovery of Euclidean space and embrace scientific perspective. With all of life pervaded by a new concept of personality, it is natural to find the "portrait" reborn during the 15th century.

Art, once it had recognized a legitimate reference to natural form, did not break away from this concept. While the history of ideas and of artistic creation was in continuous flux and in a process of development, nevertheless, during the following centuries of growing subjectivism, reality, individually visualized, remained the dominant concern of art. The pre-impressionism of the 17th century, as exemplified by Rembrandt and Velasquez, certainly no longer emphasized the abundance of realistic detail; yet visible natural form was the prime intent. Even when the work of the 19th century impressionists caused the laws governing structure and spatial relations to be relaxed, this concept did not change basically. It was not until

shortly before 1900 that a counter-movement arose among philosophers, poets, and artists alike against rationalism and materialism, and that new metaphysical aspects began to undermine naturalism.

It was Cézanne who first attacked spatial rules — rules which had been in effect for hundreds of years. Soon his followers evolved much more far-reaching theories of construction and abstraction. Picasso, to be sure, is not solely responsible for the new movement which neglected the individual — that is to say, the dehumanizing element in modern art — but he became its high-ranking representative. While Giotto laid down the conditions for a long-lasting realism, it was Picasso and his young contemporaries who abandoned corporeal harmony and the laws of a naturalistic imitative art. Interest was now diverted to constructivism, of which Cézanne was the forerunner, or to expressionism, as first developed by Van Gogh. New meaning was born to art, and artists tried to conceive fresh ways of expressing feelings, emotions and ideas. This could be achieved only through the use of symbols.

The symbols of contemporary anti-realism do not derive from the ideas of Christianity, since the modern artist stems from a cultural environment completely different from that of the mediaeval artist. Whatever the reasons for the new trend are — and there may be deeper religious roots than we realize — modern art, as personified by Picasso, is so far removed from the naturalism of the 19th century as to suggest, by contrast, a complete disembodiment of matter.

We might, for a moment, dwell on the parallel of Giotto and Cézanne and their basic concepts of space. Giotto replaced the symbolic space of his predecessors with an illusionistic stage on which his figures acted. However, it is not

yet, as we have pointed out, the mathematically constructed space of the Renaissance. Giotto, rather, created subjective space. He knew how to use a simply modeled rock as the necessary background for a group of figures, or how to make a long diagonal ridge of a hill the backbone of a spatial construction. We cannot, therefore, characterize his laws of composition as purely realistic. His illusionism is, as we said, subjective; it is almost poetic. Thus, Giotto stands between the mediaeval concept of abstract spatial relations and the recognition of Euclidean space by the artists of the Renaissance.

Cézanne played a very similar though opposing rôle in modern art. Certainly he did not destroy the scientific laws of space deliberately, but his composition turned toward an abstract ordering of nature in which scientific perspective became dispensable. Like Giotto, he represents a most remarkable point of transition. Both are involved in the problem of application of subjective space. Both Giotto's and Cézanne's laws of construction originate in their own subjective judgment and in their individual artistic sensitivity. In his arrangement of subject matter according to a thoroughly planned organization of the picture plane, Cézanne almost seems to be pointing back to Giotto. Both have a strongly marked feeling for space-creating mass and volume.

Let us consider Giotto's mural in Florence representing St. John on the Island of Patmos. The island, though seen three-dimensionally, is neither constructed according to scientific perspective nor provided with naturalistic detail. Combined with its high horizon line, however, the landscape becomes an intrinsic part of the whole compositional space. Furthermore, Giotto avoids a purely symmetrical order of the

figures: Christ is not placed along the center axis above St. John, and the four angels correspond to each other in movement only. Thus, the figures do not seem fixed in the semicircle, and they almost give the illusion of solemn rotation.

Cézanne clings to a similar subjective and dynamic space. "The Bathers"—the subject again and again attracted Cézanne—differs from all preceding landscape and figure-paintings in that the subject matter as such has lost importance, while gaining new significance through the purely abstract considerations of balance between figure and background, and an abstract ordering of the picture plane. It is this that leads Cézanne to the conception of his later landscapes, where a mountain becomes less and less naturalistic, while fulfilling to a greater degree an artistic function in the composition. Though the subjective, dynamic space of Giotto and Cézanne can be compared, it is necessary to draw such parallels with certain reservations. For example, the modern artist applied modulations and balance of color areas in a way which could only have been possible in the era of post-impressionism.

Before entering his cubistic phase, Picasso treated space rather as Cézanne did, though less dogmatically. Alfred Barr, in this context, speaks of an "unpretentious, natural mobility of order". Yet even in that remarkable monument of transition, the large painting *Les Demoiselles d'Avignon* (1907), Cézanne's principles of composition are still recognizable (particularly in his many preliminary sketches). But since this work leans to anti-realism, to distorted and cubic forms, "natural" space and depth, and atmospheric elements are dispensable; instead of them there is an organization and coordination of compositional parts, held together by dynamic tension and in perfect equilibrium. This remains the character of the later ab-

stractions: the huge *Guernica* or any of Picasso's canvases. They are growing into all-over patterns of a strictly abstract order.

Thus Picasso's art definitely withdraws from concepts of space that had been valid throughout centuries and had begun to waver under Cézanne. Now the way was free for a new anti-realism that had and has to depend on picture organization, on balance of forms and on the build-up of color combinations.

It was under Picasso's leadership, about 1910, that faith in naturalistic art was completely swept away. Representationalism, for the first time since the days of Giotto, was decisively renounced.

Thus, Giotto and Picasso stand as two polar figures, each witnessing the close of a long era and each powerfully influencing the direction which art would take in the emergent period.

Similarly, one may compare Giotto and Picasso in terms of their psychological make-up. Again, these great figures stand in contrast to each other, each representative of a different personality type. Delving to the roots of artistic formation, we will find that the transposition of reality into the inner image of an artist's creative imagination takes place, essentially, in one of two ways: the stimulation of artistic perception may arise directly from the outer world—or it may proceed from inner emotions; objectively given forms and laws may be accepted as binding—or the subjective impulse may recognize the object from *within*, and at times radically change the outward experience.

In general we may say that Giotto belongs in the first category, Picasso in the latter. But, of course, no great artist

can be characterized as following solely one or the other of these psychological patterns. Nor does any whole period exhibit one or the other tendency exclusively. During the 15th century, for instance, when artists customarily began with the observation of the outer world and its laws, there were individuals whose perception tended—to a certain extent, at least—toward the recognition of the supranatural and infinite. And if, as it now appears, abstraction is to predominate for a long time to come, there is no doubt that we will find individuals or entire groups for whom a certain naturalism will be essential—which is to say, whose artistic formation will start from the recognition of the outer world.

In Giotto and Picasso, two pre-eminent yet antithetical figures, we seem to see epitomized the two basic psychological possibilities of art expression. Giotto ushered in a long era in which the organic pattern prevailed; Picasso is the leading exponent of a new dynamic trend which we may see, in turn, as foreshadowing the future.

In conclusion we may say that Western art has produced, throughout history, both the realistic and the abstract approach to art. This must be understood along with the assumption that these phenomena mutually condition one another. Both, as we have indicated, are deeply rooted in the psychology of Western man. It has been, and quite probably will continue to be for a long time to come, the fate of Western art to find its position between these polarities. It is unquestionably an extremely complex matter to decide, in terms of either history or psychology, what underlying laws govern the manifestation or the suppression of these basic impulses of self-expression, and at what given time the one trend or the other may be said to appear, to have gained the

ascendancy, or to be receding. And rare indeed, in the course of history, have been the individuals who, in the manner we have shown, were capable of epitomizing the direction of art as clearly as did these two great painters, the one at the opening of the 14th century and the other at the beginning of the twentieth.

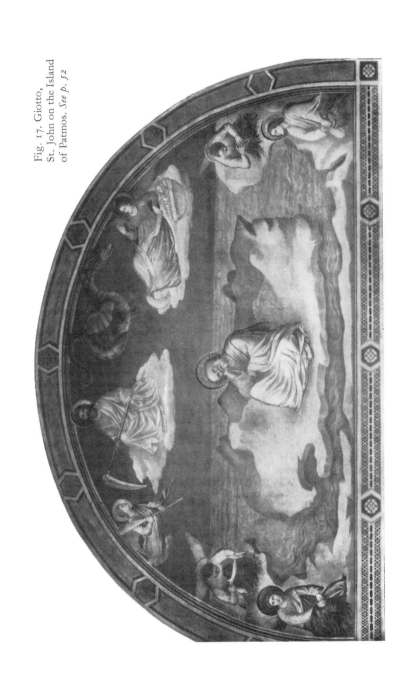

Fig. 17. Giotto,
St. John on the Island
of Patmos. *See p. 52* *See p. 52*

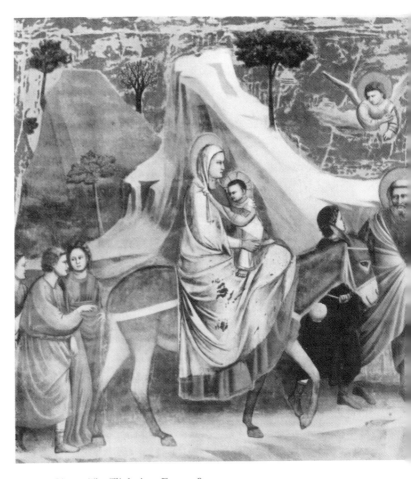

Fig. 18. Giotto, The Flight into Egypt. *See pp. 25, 53*

Fig. 19. Cézanne, Bathing Women. *See p. 53*
Fig. 20. Cézanne, "Mont Sainte-Victoire". *See p. 53*

Fig. 19

Fig. 20

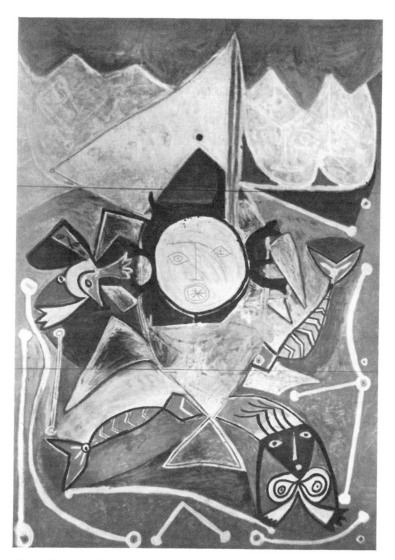

Fig. 21. Picasso, "Odysseus and the Sirens". *See pp. 53, 54*

IV

THE CONDITION
OF MODERN ART
AND THOUGHT

I

The artist's concern is reality in its deepest meaning — reality of which he is a part. He, like the philosopher, is always in search of reality. For it is not anything stable; it is oscillating, and it comprises not only the visible world but also includes feelings and emotions. It manifests itself as something static, and yet as motion and dynamic flow. Therefore artistic creation is open to innumerable solutions, depending on the artist's discrimination as to what seems to him the most adequate expression for reality. How, under these circumstances, could it be possible to set up aesthetic rules? Yet man has always sought to establish them. Greek classic art built up standards of corporeal harmony which seldom lost their validity in Western art completely. However, since the transformation of the outer world follows the inner picture which the artist's mind creates, great artists can become great destroyers in overrunning long established aesthetic regulations. The artist himself, to be sure, does not stay completely alone with his new formulation of reality — he in turn may be indebted to phenomena for which we do not always find a logical explanation. There might be a general crisis of culture of which

he becomes a characteristic exponent—in some cases he might be its prophet.

There is no doubt that modern art has its roots in just such a period of crisis. During the past few decades human thought, artistic expression, and aesthetic rules, have been in the process of change and ferment.

The concept of beauty was formerly associated with a harmonious setting and a wise equilibrium of subject matter. Such harmonious rendering gives rise to a sense of pleasure in the spectator. He will also agree to a certain simplification and stylization so long as it idealizes nature as he sees it; but decomposition and deformation he will not allow. This, however, is a one-sided aesthetic appreciation of art, which we may call neo-classic, and which by no means does justice to every kind of artistic creation.

Since art is not imitation, but really begins where imitation ends, the way is open not only to slight simplification and stylization of natural forms, but also to much stronger changes which emerge from the subjective experience of the artist. His starting point is nature, but his personal inspiration leads him to a highly imaginative picture, in which the forms are, so to speak, shaped from within. This approach to art, which prevails today but which has also been manifest in many ancient periods, leads to creations in which harmony does not play a dominant role. It would be erroneous, however, to criticize them for their so-called lack of beauty. In fact, neo-classic aesthetic criticism goes back to standards of life which were formed under the impact of humanism and the culture of the Renaissance. Beginning in the late 19th century, however, great artists began to break with the standards which had survived the centuries. Against the background of these changed

principles and this definitely new approach to nature, humanistic/neo-classic art criticism is out of place. For that matter, it never did have universal validity, and its regulations covered only certain periods and portions of Western art.

Contemporary art goes very far in the direction of dissolution of form, of decomposition and abstraction; but we must be aware of the fact that, during the last few centuries, anti-realistic and subjective elements have always accompanied the development of an art which relied basically on visible nature. Accent upon nature, on the one hand, and stress upon content, idea, and symbol, on the other, have always existed. The history of art throughout the centuries could be written as the history of this conflict. The problems involved in this struggle are much deeper than aesthetic ones; words like "beautiful" or "ugly" certainly do not go to the root of the matter.

Though modern times have changed art in its very essence, contemporary art belongs to the permanent flux of history and cannot be considered as an isolated phenomenon. Art and style are always specific realizations of the life of man, woven into the dynamic pattern of history. Thus, even some of our modern problems will appear as perpetual ones in history. The solutions, however, are always changing according to the changing emotional climate. Yet, since artists are forever striving to solve the same problems, they sometimes come very near to each other, so that we find affinities between works of art separated by hundreds, even thousands of years.

Those who refer to the harmony of Greek art are often unaware that the "classic" period was a rather late and a relatively brief one in the history of Hellenic art. If we go back as far as very early Archaic periods, the human body in re-

presentation is changed into a ritual figure tending to abstraction. Even as late as 800 B. C. the figure of a horse appears semi-abstract, and not too long before the beginning of the classic style, about 600 B. C., the ceremonial requirements of Greek life are reflected in the sculptures of the temples. It was not until after the 5th century that the masters of classic Greek art took the human body itself as the measure of aesthetic rules and laws, in which the harmony of the figures is based upon the harmony of physical proportions. The harmonious character of the classic sculptures, however, began to fade in the Hellenistic centuries following Alexander's death. Dynamic elements were favored instead of static ones. The outbreak of pain and fear in the faces underlined the new emotional elements. The Laocoon group may suffice to prove how far the new ideals had shifted from the purely classical concept.

However, it was not until the first centuries of the Roman Empire that the classicism and illusionism of late antiquity was effectively undermined by growing art concepts which led to a drastic change in aesthetic values. The Orient had invaded the West with new religious ideas; and it was thence, from Asia, that new artistic concepts such as two-dimensionality infiltrated Roman naturalism. Early Christian art favored a great simplification of forms, leaving behind laws of perspective, neglecting portrait and landscape. It emphasized the content, expressed religious significance, and exploited the spiritual. By 500 A. D. this expressive language of art had spread throughout the main cultural regions around the Mediterranean Basin—to Byzantium, Egypt, Italy, and elsewhere.

For hundreds of years, until the 12th and even the 13th century, the prevailing concepts of art set expression and

symbolic meaning above realistic appearance. The trend away from visible nature and tangible form became very strong in Ottoman art, flowering from the end of the 10th to the middle of the 11th century. It reached a style of high transcendentalism. In the monastery of Reichenau, and later in other monasteries in Germany, paintings originated— especially book paintings—which were great masterpieces of a semi-abstract beauty. Similar to them, and perhaps even more abstract, are the contemporary illuminations of the "Beatus" manuscripts in Spain.

This fully established, exalted and transcendental art fore-shadowed the coming centuries, the styles of the high Middle Ages; but during the Romanesque period a counter-movement developed which began slowly to supersede the symbolic approach in art.

This semi-naturalism broke through in France in the 12th century. The spirituality and aloofness of the hieratic styles changed into an imagery which, while still severe, began to allow itself the reproduction of natural forms. This new trend in the visual arts represented the attempt to rediscover the individual without losing contact with the supernatural.

It was about the middle of the 13th century in Italy that Niccolò Pisano, supported by his knowledge and under-standing of Roman antique sculpture, gave his figures and groups a new existence in space. The hieratic character of mosaics and murals began to fade, and high stylization was relinquished in favor of forms which betrayed the study of physical nature. It was at this time that the leadership passed to the Florentine painter, Giotto di Bondone, and it was his genius which brought to final completion the new synthesis of naturalism and idealism in Western painting.

Giotto's contemporaries and immediate successors found themselves almost confused by the master's realistic tendencies. They assimilated them into their own art but slowly and with reluctance. Yet no force could stop the growth and expansion of this new naturalism which was also permeating philosophy, poetry, and the sciences as a trend toward the rational discovery of nature. A hundred years after Giotto, with Masaccio in Italy and the Van Eycks in the North, scientific perspective and the recognition of Euclidean space had been introduced. The new three-dimensionality called for a matter-of-fact illusionism. Everything tangible became important as such—that is to say, as a visual object. It is not surprising that the art of the portrait, which had lain in oblivion for hundreds of years, was reborn in the 15th century.

This vogue of portraits, due to man's urge to see his own features, his own self reflected in a work of art, belongs to the realistic tendency and the individualism that remained as unwritten laws from that time to the late 19th century. However, the tendency to escape from pure naturalism and to stress content, idea, and emotion never ceased altogether. Even during the period of first pride over the conquest of visible nature, some artists, especially in the northern countries, tended to strong expression and symbolism. The emotionalism of Mathias Grünewald, and the mystic world of Hieronymus Bosch are well known.

The genius of Michelangelo in the 16th century set aside the ideal of static harmony. For him, form was only the starting point. From there, form had then to be imbued with significance—with expression. It was his own emotions, his individual struggle with God, which then appeared reflected in his artistic creation. When, as an aging man, he sculped the

Pietà, he took little heed of details of natural form. These bodies express pain — one might almost say it was his own inner pain that called for realization in stone and was transformed by his genius into a symbol of universal suffering.

In Venice, Tintoretto was infusing his subject matter with his own profound understanding of drama and human unrest; and he, in turn, was the master of a young Greek who afterwards developed his visionary art in Spain. El Greco's deep emotionalism dramatized even his landscapes. He left classical movements far behind him and did not hesitate to distort his figures in order to heighten their expression.

Rembrandt began to develop his art at a time when the growing philosophy of capitalism and the general bourgeois approach to life were on the side of sound, matter-of-fact naturalism. But Rembrandt's reality is a world of intimate subjective faith. His humanity, and El Greco's emotionalism, became important ferments of modern art.

During the 18th century new ideas had begun to conquer the world. The French Revolution was the first momentous clash in the formation of new classes. There could be no doubt that the fight for human rights and democratic ideas would affect the visual arts deeply. But the true consequences of the cultural alterations in art made themselves strongly felt much later, some hundred years after the French Revolution.

The only contemporary whose art was profoundly affected under the immediate impression of revolution and the Napoleonic Wars was Goya. His deep humanity rebelled against terror and against the misery and suffering of man. He did not hesitate to show hideous brutality and cruelty in his etched horror scenes which have lived on as effective symbols of the errors of human life. His paintings influenced Manet but his

moral outlook, as found in his graphic work, makes him the predecessor of modern expressionism.

In the 19th century the problem of the approach to life and nature was first characterized by the issue of romanticism versus neo-classicism, so clearly epitomized in France by Delacroix and Ingres. The romanticists understood deeply that the appearance of an object depends upon the subjective approach of the artist (see appendix on romanticism on page 93). It sounds rather prophetic, and not unlike the credo of a contemporary artist, when Novalis, the German romanticist, says: *Der Baum kann mir zur blühenden Flamme – der Mensch zur sprechenden – das Tier zur wandelnden Flamme werden.* — "A tree to me may be a flowering flame — man, a flame that speaks, and a beast, a stalking flame."

It was then, in the second half of the 19th century, during the period of growing faith in the autonomy of science, that a most remarkable outburst of naturalism opened the way to impressionism. There was an unlimited new confidence in the visible world, which was approached with the utmost directness, relinquishing the conventions of the day, the academic and formal. Manet's picture, "Déjeuner sur l'Herbe", is still reminiscent of earlier laws of composition, but even so, it is witness to this new free and self-confident approach to nature. The élan of the pure impressionists, however, found its antithesis in other artists who felt the imperative inner need for a much more subjective self-expression.

Van Gogh took over the palette of the impressionists, but within a few years he had created something very different from the impressionistic illusionism. Starting from his own profound and tragic conflicts and his religious fervor, he achieved a symbolic portrayal of nature. His colors no longer

matched those of nature; they originated, rather, in his emotions and changed external reality into a visionary image of his exalted fantasy. The other great figure who cleared the way for an anti-impressionistic movement, Cézanne, pioneered a more rational development in art. Cézanne was the initiator of new laws of composition and of such principles as the activation of the surface of the picture plane and the breaking down of the individual form geometrically. Van Gogh's profound emotionalism paved the way for 20th-century expressionism, whereas Cézanne's work led to constructivism and cubism.

II

During this brief historical survey, we have seen that, in those centuries in which external reality was emphasized, there were always artists who sought to go beyond realism and to stress content. For almost six hundred years, however, this tendency had never gone so far as to result in an actual disintegration or destruction of natural form. In other words, art had never returned to the strongly symbolic forms of the early Middle Ages, nor to the distortions and reduction of forms to be seen in archaic and primitive art. About the beginning of the 20th century, however, the crisis became very grave—perhaps even graver than had been the case some six centuries earlier, when symbolic art was repressed by the new faith in naturalism. This time, very roughly speaking, the reverse was true. Concepts of "beautiful" and "ugly" were certainly not at stake. It was the fight for a new truth, and under the impact of this struggle the disembodiment of the individual figure and the shattering of natural forms took place. Artists wiped out past

forms because they wanted to avoid associations and to stay free of any kind of pathos or romanticism. They abandoned illusionism in favor of an almost metaphysical reality. As the writer Apollinaire said, "Real resemblance no longer has any importance, since everything is sacrificed by the artist to truth, to the necessities of a higher nature. The subject has little or no importance any more."

The fear of false pathos and outdated forms was felt by musicians and poets as well as by painters and sculptors. Gertrude Stein complained of what she described as "just worn-out literary words" from which "the excitingness of pure being had withdrawn ..." Her endeavor to reorganize poetry was a conscious attempt to restore vitality to the noun. It was Stravinsky who sought to remove all vestiges of sentimental and moral associations, and even emotions from his music. To create order, no less, was his motivation — or, as he himself expressed it — "... the ordering of a given number of tones according to certain intervals." This, too, was Arnold Schönberg's endeavor; as early as 1914 he had proclaimed a new unity and order for his music.

Henri Matisse never gave up natural form. But when in 1905 he became the leader of the "Fauves", he composed in non-naturalistic, violent colors — colors which were in strong contrast to the harmonious palette of the impressionists. Later he increasingly stressed a "peinture pure" in which planes of pure, unmixed color were arranged side by side in a very distinct coloristic order.

The cubism of Picasso and Braque, developed fully by 1910, certainly signified the strongest break from naturalism; an endeavor, to some extent intellectual, to attain what they wanted — namely, a new truth. Today we know that this dis-

solution of form into geometrical and semi-geometrical shapes was destined to be of great importance in the later development of the visual arts. Its underlying elements may yet be effective in determining the direction future art will take.

Though Paris remained the principal center, the movement was an international one. Almost contemporary with the cubism of Picasso and Braque, Franz Marc and Kandinsky followed their own original directions in Munich. Marc, nevertheless, did not leave the realm of nature completely behind. His distortions, semi-abstract forms, and geometrical patterns gave rise to an imagery based upon purely artistic considerations of composition and construction, expressed though it was in terms of a new anti-naturalistic coloring.

Kandinsky's world is very different. He left Russia where a group of artists had already tried to break away from out-dated realism. He characterized the essence of his art as a spiritual one in order to make clear that a process of spiritual-ization changes objects into organized patterns and colors. In fact, Kandinsky not only stylized, abbreviated, or distorted forms, but he became the founder of the so-called non-objec-tive art, in which the painting lives entirely detached from natural forms. It was his mathematical brain which led him as a painter to the invention of patterns in which the individual elements of lines, dots and color areas are held together by compelling tensions.

Only a few years younger than he was Mondrian, for whom logic and mathematics were indispensable, too. His experi-ments led to carefully calculated square planes, kept together by strong tension. Beyond painting, they won particular significance for contemporary architecture. In the field of

sculpture, Brancusi and Archipenko contrived abstractions which gave a new meaning to plastic values.

In Italy, before World War I, Marinetti and Boccioni began to shock the public with their manifestoes and literary and artistic creations—an almost wild avant-garde movement. During the second decade of the 20th century, Chirico became the leader of a group of painters who characterized themselves as "Metaphysicists", thus indicating their program of striving to put down in paint the real essences of things behind and beyond visible nature. In fact, painters such as Chirico never completely discarded what nature offered. They rather created a highly plastic, unreal world of their own—often with the support of geometry and cubic forms in which human figures were replaced by metallic phantoms.

Meanwhile, in Paris, Rouault had become the most important representative of an art which found new spiritual values without ceasing to recognize natural, tangible forms. His emotional fantasy created an atmosphere of hieratic austerity which enabled him, more than any other modern artist, to parallel and equal the aloofness of medieval art, as we find illustrated in the great number of his representations of Christ. The spirit, however, is the same that permeates any of his other subject matter. In his clown portraits, which are his favorites, the artist transforms their unhappy souls into symbols of misery and distress. "Christ on the Lake of Tiberias" affords a striking example of how his subjective experience shaped the landscape from within and thus completely changed its outward character. Rouault's transposition of visible reality into the artist's creative imagination and emotion gives rise to a new beauty, certainly no less valid than any which results from classical concepts.

The Condition of Modern Art and Thought

A similar emotionalism had led the Norwegian, Edvard Munch, even before 1900, to digress from natural form in order to stress anxiety, sickness and the threat of death; and soon thereafter various German artists, such as Emil Nolde, were similarly impelled to a strong expressiveness.

The most conspicuous artistic genius of our era, Picasso, was deeply impressed in his youth by his Spanish precursor, El Greco. He is linked to the Expressionists by his interest in the purely human condition of man, above all, that of the poor and the oppressed. This tendency derives from the struggle for human rights which burst into being in the late 18th century, one of the deepest roots of the new expressionistic art.

While the more rational trend in art broke radically, as we have pointed out, with tradition and specific associations, expressionism can be interpreted as an artistic realization of a long development in human thought. When Picasso, like Rouault and others, handles the problem of depicting misery and destitution, it is, to be sure, no longer a question of the subject matter alone; these pictures move and affect us through artistic means, through exaggerated and distorted forms and through colors, the quality and intensity of which convey the content better than any naturalistic narrative.

The human element is by no means lacking, even in a painting of Picasso's which is reminiscent of Negro sculpture, as we see in *Les Demoiselles d'Avignon*. It was during the first decade of the new century that artists developed a vivid interest in primitive art. This tendency was first wrongly interpreted as a sudden emergence of snobism. On the contrary the universal trend toward bringing the alien imagery of bygone centuries or of living primitive art into the orbit of Western

artistic imagination stems from an interest in everything that is human. It is as though aesthetic rules to which we had long clung had been preventing us from recognizing another kind of artistic expression and beauty which, though it cannot be measured with the neo-classic yardstick, is none the less worthy of respect for its own human-ethical (and even religious) values. The new approach has meant a tremendous widening of the artist's horizon, whether he has studied the expressive art of early China or Mexico, of ancient Egypt or of prehistory, African sculpture, or masks from the South Seas. The reason artists showed so keen an interest in these arts was that they found a deep kinship between them and their own aims.

One may compare a modern sculpture, say a bust by Modigliani, with a South Arabian sculptured head from the first century A. D. Those who are trained in neo-classic aesthetics will certainly be perplexed in either case by the distortions. The fact is that organic clarity and static rules have become less important and have been replaced by dynamic impulses. Rouault may never have consciously drawn from primitive sources; yet there are African masks which look as though they had served him as models.

There is a bronze head by Picasso which makes us think of the exotic rhythms of ritual statues or totems. It may be shocking in its appearance, but the strange exaggerations of form certainly have their distinct purpose. We can again point to the indigenous sculptures of the Americas, or to African art: the exotic character of those sculptures has never been questioned, but it was, as far as I know, only Miss Stein who perceived the *ritual* character in Picasso's work.

For several years Picasso, the cubist, represented the rational trend of modern art. Later he often turned to realistic

forms, or to a realism heightened by strong expressiveness; he even combined abstract and semi-abstract forms with expressionism. In his almost naturalistic sculpture entitled "Man Carrying a Lamb", it is the expressive, the dramatic character which is decisive. The man is no specific individual—he is man as such, who has power over beast. Picasso brings into focus the animal's shyness and anxiety, which are concentrated in its wide-open eye.

Even in his greatest creation, the Guernica mural, in which many find a radical abolition of external reality, the most striking expression of human life and suffering has been achieved. Whether the mural moves us by naturalistic means or by symbolic interpretation is a secondary question. Goya drew similar horror scenes, and it was certainly not his crude naturalistic approach which caused the spectator to shiver, or which made these renderings famous as symbols of human cruelty and stupidity. It was the particular artistic presentation which his artistic genius had found. Similarly responsible for the immense impact of the Guernica painting is Picasso's new artistic language, which expresses life and tragedy in accordance with our new psychological experiences.

When we approach the work of Paul Klee, we enter a completely different field of creative self-expression. Klee generally made very small paintings, executed partly in techniques of his own invention. They are full of enigmatic symbols and abbreviations—of stylized forms or pure patterns. They are equally as far from a purely decorative character as they are from deep emotions. The world of Paul Klee is a highly irrational one; he begins with nature but from there plunges into the world of dream and fantasy. It certainly would be erroneous to assume that there is no rational con-

sideration of construction in the way he conveys to us his dream-like visions. Each of them follows its own rules.

"The Legendary Town", painted in 1920, will convince everyone that each detail has its definite place in the whole of a very conscious composition; yet the geometrical lines and planes grow together to an almost magical unity, and the most delicate color scheme belongs to this very vision; it could not be repeated in any other picture.

The unusual hues of the picture "City with Flags" proves how certain colors are part of the artist's unique conception. Again, absolutely different is the composition of light colors in the painting, "Realm of Birds". The abstraction here goes so far that, beyond the little birds, only a few forms in the picture call to mind naturalistic objects. The picture is a highly imaginative conception.

When cubism began, Guillaume Apollinaire tried to assert its value, and the manifestos of André Breton sought to justify the new phenomenon of surrealism. Klee, also a musician of rank, relied on his own inner voices and explored a new field of artistic creation without the benefit of an Apollinaire or Breton as vanguard. He teaches us that painting growing out of creative imagination can reach universal validity and new beauty.

Occasionally Klee tends to pure abstractionism; some of his linear configurations follow a certain drive—a circular or spiral movement. From here it is only a step to the work of Calder, whose mobiles fulfill the contemporary urge to overcome static elements completely and to combine form and line with motion and rotation—in other words, to intermingle space with motion in time.

A short digression may illustrate the same phenomenon in contemporary architecture. The idea has now been relinquished

that a building grows out of the earth like a tree; that some parts, such as columns, support others; and that the building as a whole has its specific static meaning and organic growth. The old idea has been so completely reversed that even the connection between the building and the ground has been reduced to a few thin pillars, so that the building appears to be suspended in space and not supported by the earth at all. Even the external appearance has been changed from the solidity of stone to the lightness of glass and steel; so that we no longer have the former emphasis on organic, static unity. Such structures as the United Nations Building and the Lever Brothers Building in New York appear almost dematerialized; they are monuments of architecture as well as masterworks of engineering, and their great attraction lies in their dynamic effect of rising from the ground like fountains, dazzling in translucencies and reflections of light.

One might also point to the modern conception of the residential home. No solid walls denote the character of the shelter, of the home where the individual feels protected from the outer world. Rooms are no longer units by themselves; instead, space flows unconfined from indoors to outdoors. Shelter and the elements are separated only by the transparency of a glass curtain.

To return to painting: Klee's work is unique in its synthesis of irrational dream elements with the highest artistic discipline. Yet he has had great influence on his contemporaries and on the younger artists. Even strong personalities like Miro and Feininger are indebted to him. One of the finest contemporary American painters, Mark Tobey, is hardly explicable without Klee as a precursor, yet his art is not dependent on him. Even pure abstractionists are related to Klee. Like him,

they all start from a certain natural perception, but they completely suppress naturalistic elements. In the manner of visionaries they experience certain vibrations when facing the object and they try to find an artistic expression for these subjective impulses. Thus they are, as it were, painting their own emotions and ideas. Gorky's "Agony" (1947) evolves from a dreamlike abstraction spreading over the canvas in fiery, luminous colors; brush strokes, color spots, and linear configurations converge in a wisely balanced composition. In Roberto Matta's picture "The Disasters of Mysticism" (1942), a vision of world cataclysm is painted in which some naturalistic elements are still recognizable. Janet Sobel's painting "Music" (1944), however, is one of those overall patterns which reflect the painter's feelings as evoked by music. (In France, a whole group of so-called *Musicalistes* had arisen in the thirties, who equally followed musical impressions.) Innumerable artists followed this new kind of self-expression in Europe as well as in America and Japan. The enormous output of such abstract works throughout the world affords testimony in itself to the necessity and sincerity of this movement.

III

Modern psychology has helped to free man from conventionalism and to endow him with almost unlimited freedom. The artist too was made free, but at the same time he found himself completely alone. He was allowed to rely on his own feelings, emotions, and dreams; but there was no dogma or tradition to help him realize his subjective visions—no other, at least, than his own conscience.

It is this unlimited freedom which is responsible for the extreme deviation from nature developed by individual artists and many groups. Among the latter, surrealism may be called an almost pure by-product of modern psychology. Its disciples rely upon the unconscious, upon their hallucinations and dreams, for their subject matter. They do not, by this, renounce the painting of visible and tangible objects; rather, they dismantle the corporeal entities, change them into lifeless puppets riddled with holes, and combine detached limbs or anatomical constructions with naturalistic or imaginary landscapes.

Contemporary art has not, any more than contemporary science, abolished reality but has opened the way to a new concept of what is "real". Picasso, even when he approached nature through abstract means, declared that for him it was only a way to reality. Kandinsky, the non-objectivist, bitterly complained that the public thought his starting point to be rational analysis, whereas, he asserted, it was practical experience from which his theories emerged. Paul Klee, teaching in the Bauhaus, advised his pupils again and again to study nature and take their inspiration from it.

It will be appropriate here to point to the new concept of reality in modern poetry. Poets, no less than artists, have found themselves searching for the answer to the question: What is reality—how and where can we grasp it? Rilke, in his late poems, came to the conclusion: "Everything is not itself." ("Alles ist nicht es selbst.") There is nothing which is not subject to this dualism. Flowering and decay, as he puts it, are experienced at the same time; the frightful appears with a smile. In the work of T. S. Eliot similar antitheses may be found: "... only health is the disease ..."; "... in my beginning is my end ..."; "... life is death ..."; "And where you are is

where you are not." Thus, since everything bears its antithesis within itself, polar contrasts fade away. The all-understanding mind of the poet finds a synthesis of contradictory elements—just as the all-catching eye of the artist finds a new synopsis of separated phenomena. In poetry as well as in the visual arts, the concept of reality has attained a new significance.

If the new reality is no longer a static one, it is quite understandable that the language of poets no longer lays stress upon logical analysis. Theirs is a dynamic character of thinking; it abandons the logical sequence of thought. Poetic images follow each other abruptly. At first sight, they appear incongruous, but they reveal their consistency in the sense of a higher, purely poetical unity. This metaphoric language creates bold poetic analogies which not infrequently perplex the unprepared reader. With the aid of these symbols, often couched in cryptic language, the poet tries to come nearer to "reality" than he could by any realistic approach. We might almost speak of a *moral* reality surpassing pure experience, which has "only a limited value" (Eliot). Like the artists, the poets strive for a more absolute reality, transposing their subjective emotions into correlates of objective validity. These correlates may arise from the unconscious. As early as the mid-eighties, one of the most gifted French poets, Jules Laforgue, calls on the unconscious to descend and replace our foolish and limited institutions with genuine values:

> *Inconscient, descendez en nous par reflexes:*
> *Brouillez les cartes, les dictionnaires, les sexes.*

Later Paul Valéry puts it bluntly: "Le songe est savoir" (to dream is to know). Thus experience appears transformed into

dreamlike pictures and symbols. It is not always possible to decipher the language of symbols. In Rilke's "Malte Laurids Brigge" (1910), the sight of the ruins of ugly walls in a partially torn-down Parisian slum changes, through the poet's imagination, into the life of its former inhabitants. These very walls themselves, to the poet, are now sickness and the breath of perspiration, the odor of babies, warmth of beds and smell of feet. Here the transposition of the subject matter into a vision of lives of destitution and misery can be easily understood. On the other hand, Valéry is much more abstract when he paints his vision of the quiet sea and moving sails by depicting doves walking quietly on a roof-top:

> *Ce toit tranquille, où marchent des colombes,*
> *Entre les pins palpite, entre les tombes.*

The metaphors "roof" for "sea", and "doves" for "sails" would hardly be intelligible if the sea were not mentioned a few lines later.

Among the sonnets of Mallarmé there is one which affects us like an hallucination. The poet brings us under the spell of a dreamlike icy landscape and a white swan, at once spectral and real. We find a strange beauty in this mystic atmosphere and in the swan which cannot fly. It would be impossible, however, to understand this poem by taking it word for word, or to explain it by mere logical analysis.

There was one outstanding French artist who, about 1880, developed a similar symbolism in his painting and graphic work, and that was Odilon Redon. He shows us in his "Apocalypse" a vision of a landscape such as Mallarmé's; it contains realistic elements, yet seems to emerge from the world of somnambulism and dreams. We are fascinated by

many of his lithographs even if we cannot find any rational explanation for the phantasmagorias of his inner eye. From the black backgrounds of these lithographs strange creatures appear, or parts of bodies—the decapitated head of a young girl, an eye half transformed into a balloon—or animals which seem at first glance to be real creatures but quickly change into strange phantoms.

No other artist shows more clearly than Redon that romanticism has revived in symbolism, which in turn leads the way to abstractionism; there is no doubt that Redon points strongly to the future—that he foreshadows surrealism, and that, in a way, his most powerful successor was Paul Klee.

With Mallarmé's poem in mind, we may now refer again to Klee's picture, "Realm of Birds", painted some thirty-five years after the French poet's vision of the swan. We find that these birds too could hardly begin to fly. They live in surroundings that lie beyond intelligible explanation. The abstract pattern gives just enough naturalistic indication to suggest the existence of a landscape. It is indeed difficult to carry through the comparison of the poem and the painting. Mallarmé's swan grows to deeper symbolism. It may be explained as the poet's soul, yearning to fly; it may be interpreted even more broadly: the earthbound frustration of the swan is shared by every one of us. Klee also seems to conceal a deeper meaning. In the semi-abstract portrayal of his "Realm of Birds" we discover four crosses, and the sun and the moon. Did the painter feel a religious symbolism in creating his work? The crosses seem to indicate this, and we may recall that the sun and moon always appear in representations of the Crucifixion.

Before concluding our consideration of the French poets, we must still point to the fact that with all their symbolic

imagination, their dynamic and often cryptic language, they never discard the severe form of traditional verse. It is well known that Baudelaire, with all his powerful emotionalism, tends toward the classic in the formal aspects of his poetry; it is equally well known that Mallarmé was one of the great masters of poetic form and rhythm; the same is true of Valéry. The French symbolists never cast overboard the heritage of the "Parnassiens".

If inconsistency of language and obscure metaphors can appear side by side with classic metric form in poetry, we may perhaps more readily understand how Picasso is able to combine classic form and abstraction, or that the sculptor Henry Moore shows both in his work: deviation from natural form—particularly in his bewildering hollows—as well as firmness of construction, planned mass, and disciplined line. And if we consider music—Hindemith's return to the severe form of Bach, for example, or Stravinsky's synthesis of new means of expression with classic form—we can conclude that modern poets, artists, and composers are equally sincere in applying new means to the expression of emotions and impulses and in adhering to classic measure, or at least to certain standards of classic character. (Even James Joyce has his deep and manifold roots in European culture of the past, and clings to a classic parallel with the *Odyssey*, as expressed in the title *Ulysses*.) One might see in this general phenomenon a certain destiny of Western civilization. It may not be possible—at least not yet—to completely suppress the classic Greek heritage which Western man bears in his inner self, although he has tended, again and again, to anti-humanism, to deformation and abstraction. In the last analysis, the "classic" is but *one* component of the soul, which sometimes takes the lead

and sometimes is repressed by its psychological opponents. Likewise we may see in the tendency to symbolism and abstraction, or to the apparently chaotic, another ferment of the soul. Thus we can conclude that nothing would be more erroneous than to say that poets, in using incongruous metaphoric language, are "running wild", or that the abstractions of artists are absurd or meaningless. Rather, we may recognize here the individual fight between two basic *psychological* forces and the attempt to reconcile these antithetic elements.

The process of transposing personal experience into the strata of symbolic devices leads out of traditional conceptions of space and time. In a world of symbols, localities separated by oceans can appear close together, and events which occurred thousands of years ago may be seen as elements of present day life.

We may quote from T. S. Eliot's "Sweeney among the Nightingales":

> The nightingales are singing near
> The Convent of the Sacred Heart,
> And sang within the bloody wood
> When Agamemnon cried aloud,
> And let their liquid siftings fall
> To stain the stiff dishonoured shroud.

Sweeney, in a state of reverie, stands in the night. The nightingales to which he listens are the eternal nightingales which have always sung, the same voices which could be heard when Agamemnon was murdered. The convent recalls the world of Christianity, whereas the mention of Agamemnon brings up the memory of ancient Greek heroes. The poet, without any transition, switches from the atmosphere of the tavern from

which Sweeney has just emerged into a pseudo-reality in which Christian times and the Homeric age meet.

There is a love scene in "The Wasteland" in which a tired girl comes home from her job and receives a young man in her modest little room. They represent the dullness of a generation; the girl experiences the act of love without passion, hope, or even affection. Yet the realistic situation is seen under the aspect of eternity. There was Tiresias who had predicted what would happen in the room. He, the old seer, knows that this couple is "the" couple of the past and future, and sees the timelessness of the individual act: as Eliot himself calls it, "the intersection of the timeless with time."

This same point of view has also conquered the theater and superseded the old dramatic rules. Pirandello created figures of double reality, so to speak; people who shift from their realistic existence to an imaginary world. Thornton Wilder saw nothing absurd in letting the players in *Our Town* handle imaginary objects. When the bride and groom of this play utter their feelings, they cease to be individual beings and become timeless creatures, speaking words which have been spoken throughout the centuries and will be spoken in the centuries to come. Thus, in Wilder's philosophical comedy, *The Skin of Our Teeth*, Mrs. Antrobus, when asked how long she had been married, answers: "This spring Mr. Antrobus and I will be celebrating our five-thousandth wedding anniversary." Our dynamic outlook teaches us that the dramatis personae are only in one sense bound to their own lifetime and that in another sense they have their place in timelessness.

IV

Some critics have considered the decomposition and distortion in contemporary art works and the dissolution and shattering of natural forms to represent a lack of piety and of respect for nature as Divine Creation. This view does not seem adequate. One cannot hold a lack of Christian conviction responsible for contemporary abstract art. It may suffice to point to early Christian art, which tried to overcome antique naturalism and illusionism in favor of a profoundly symbolic art. And it was in consequence of this that the whole of the Middle Ages stressed spirituality and transcendentalism—and not organic correctness or natural beauty. As we have pointed out, spiritual values are certainly not lacking in modern art. Even specific religious elements are not missing, and are strongly expressed in modern poetry especially. Where they point in directions other than Christian dogma, they do not affect it any more than does the discovery of a new physical law. Today, science explains the origin of the world and the appearance of life upon it, and finally the appearance of human beings, in a way that has nothing in common with the cosmogony as narrated in the First Book of Moses. What we are finding, however, is that humanity, as often before in history, is quite capable of recognizing the value of religious dogmas while at the same time accepting the latest discoveries of science.

Modern science has less to do with the certain and the well established than with the challenge of the indefinite and the unknown. This fact finds its parallel in the psychological attitude of modern life and art. A new personality type responds to new exigencies. We are driven away from static ideals and

must, whether we wish to or not, follow the consequences of a dynamic outlook on the world. Matter as such is something no longer firm and stable; it is energy; the universe itself is expanding. Physicists again face the unknown and have built up the "principle of uncertainty". Artists are deeply conscious of this uncertainty. One of them expressed it in these words: "The greatest adventure today is man himself and the greatest unknown, the human mind." (Gordon Onslow-Ford.) What wonder that the humanistic approach to art and classical aesthetic rules can no longer be applied? Nor can it surprise us that, having been deprived of the neo-classical canon of beauty, artists have found themselves driven in the opposite direction. Static ideals have been overruled by dynamic forces which have opened the way to the legitimacy of the non-beautiful, the abnormal.

Most of the psychological discoveries of the last fifty years have to do with the recognition of the shadowy, as it were, not the luminous sides of our personal life. It was a highly symbolic and prophetic quotation from Virgil that Freud chose in 1900 for the title page of his *Traumdeutung* (Interpretation of Dreams): "Flectere si nequeo superos, Acheronta movebo" ("If I am powerless to bend heaven, I'll stir up Hell"). He was fully aware that in this day and age, the most necessary thing to do is to fight against Inferno, against all those feelings of uncertainty and anxiety originating in the unconscious. There can be no doubt that this new knowledge of, and this struggle against the abyss of pathological fear, this somber sight of our own soul, has much to do with the lack of beauty and harmonious setting in the visual arts. Aldous Huxley speaks of our "metaphysical prisons whose seat is in the mind, whose walls are made of nightmare and incomprehen-

sion, whose chains are anxiety and their racks a sense of personal and even generic guilt."

Our anti-classical art seems to have found new expression for these metaphysical prisons, a new language for this bewilderment and fear that pervades modern life. One art critic, Walter Abell, found that the subjects of the maze and the monster play an important role in contemporary art; and it is certainly easy to find many examples of the maze type and the monster type. But for critics to declare that modern artists are depicting their neuroses is an oversimplification, and quite as much so is the cry of "nihilism". Such catchwords will never suffice to explain the highly complex phenomena of the visual arts.

Speaking of the state of mind in which fear and nightmare play a dominant role, it may be useful to revert once more to the French poets of the 19th century, and to their followers in France and in the Anglo-Saxon countries. There is no doubt that French poetry developed, in an extraordinary way, new expressions for the atmosphere of the sinister, of destitution—for the horror of frightening, desolate places, and for fearful chimeras and despair. Contemporary poets have been influenced by Baudelaire, the master builder of new French literature, and by the subsequent group of poets, the symbolists. Anglo-Saxon poetry is deeply indebted to those foremost poets of France.

Baudelaire's *néant* (nothingness) comes near to the modern feeling of loneliness and hopelessness. His "spleen", his melancholy and nostalgia, mingled with trivial, cynical and even brutal outbursts, find their continuation in the modern poet's expressions of anguish and despair. When Auden says:

... the enormous disappointment
... flings her
Indolent apron over our lives ...

we may think back to Baudelaire's words:

... *l'Espoir,*
Vaincu, pleure, et l'Angoisse atroce, despotique
Sur mon crâne incliné, plante son drapeau noir.

In his "Hymn to Beauty", Baudelaire is desperately yearning for the agent to free him from his despair. Whether it is the devil or God, an angel or siren, he cries for "whatever it is that makes the universe less hideous and heavy."

Modern writers are truly within the tradition of French poetry in their descriptions of sordid rooms and desolate, deserted streets. The streets become a part of the "sordid images, of which your soul was constituted". They are "like a tedious argument of insidious intent". "You had such a vision of the street as the street hardly understands" (Eliot).

The four people, three men and a woman, who are the heroes of one of Auden's books, suffer from desperate feelings of loneliness. The poet gave to this work the characteristic title, *The Age of Anxiety*. It casts full light on the state of mind of modern man, of a generation which is "from birth to death, menaced by madness."

The French symbolist movement found, as we have indicated, its prominent artist in Odilon Redon. Besides his tender approach to nature, in which there often appears a strong religious feeling, Redon developed his romantic dreams in the direction of the super-real, and he expressed in a most striking way the sinister and the nightmarish. He was obsessed

by his own hallucinations of fear and dismay, and we can assume that he was influenced not only by the French poets but that he was inspired by the genius of Edgar Allan Poe. Poe's first great European admirer was Baudelaire, who preferred his mystic and visionary mind to Goethe's balance. Beginning in 1852, and over the course of the next twenty years, several of Poe's works appeared in the French of Baudelaire. It was Mallarmé who first translated "The Raven", which was published with Manet's remarkable lithographs in 1875, while the first edition of Poe's poems translated by the same author was printed in 1888. Mallarmé may have been attracted not only by Poe's images of the uncanny and even the satanic, but also by his general attitude; the merging of the real and the cryptic, the natural and the ecstatic, the life of the day and the visions of the night. Redon, however, succumbed to the obscure, the uncanny, and the ominous in Poe. Around 1880, following his early period of naturalism, he turned to a world of dreams. There are pictures of deadly horror and ghostly appearance, enough to make the onlooker shudder. After a first set of lithographs called "Dans le Rêve" (1879), the graphic work in which his "surrealism" emerges for the first time, Redon, in 1882, published a new set of lithographs under the title, "A Edgar Allan Poe". Thus the artist acknowledged his indebtedness to the American poet.

We have said that in transcending the realistic into the realm of phantoms and magic patterns, Redon had no greater successor than Paul Klee, and we may now add that Klee, in a new way, found similar expression for the feelings of fear and horror. These often are expressed even in the titles of his paintings, such as "Errant Soul", "Mask of Fear", "Fear", and "Outbreak of Fear".

In conclusion, then: fear, to be sure, pervaded the human soul in earlier ages as well as our own. It has always had, however, its specific character. Each period has also developed its own particular way of combatting panic and anxiety. Magic and magical rites stood against evil in ancient times. Religion and religious poetry fought against Devil and Hell during the Middle Ages. Demonological figures, apocalyptic visions, and even satirical and grotesque renderings on the part of the artists were means of objectifying evil, and so dispelling the fear of it. Modern anguish, however, as expressed in poetry and the visual arts, has been recognized as a ferment of the unconscious and has become the subject of scientific research.

Thus, contemporary art has conquered new dimensions, which are concerned with the reactions of the unconscious. Whenever art has had this aim, it has turned to anti-naturalistic expression. Viewing it from this psychological angle, we can now perceive that the contact which modern art found with primitive art corresponded to a deep relationship and a necessity. It is no coincidence that modern psychology, in giving us, under the leadership of Lévy-Brühl and C. G. Jung, a new insight into the psychological character of primitive peoples, came to the conclusion that primitive mentality, with its orientation toward the mystic, is found in the strata of our own unconscious—without it, perhaps, art would not exist at all. Those "archaic" functions, as it were, of our soul represent the counterpart to our logical, intellectualized mentality. They lead to a perception which draws upon the images of the unconscious mind. Examples of this kind of perception may be found in ancient periods as well as in the work of modern artists.

V

Since the very essence of life has changed, and man again faces the dynamic or, shall we say, magical universe, the individual has lost something of his autonomy. Abstract art itself lays less stress on the individual than does representational art. It comes nearer to anonymous art, such as existed in medieval times. Also, as in the Middle Ages, art today has no room for the portrait. It does not center around the image of man any more. Yet we have seen that expressionism has its deepest roots in humanity, and that abstractionism and non-objective art mirror human qualities and phenomena. The new artists give symbols for feelings and emotions. The onlooker, of course, gets lost as in a maze, when he can no longer find the way to those symbols of suffering and anxiety or even exhilaration. The artist leaves us without the key to his emotional fantasy, his geometrical rationalizations, or what his personal dynamic impulses may have been. As long as the artist alone can trace his symbols back to his subjective experience, we cannot live, so to speak, in his work; and the artist, as well as the onlooker, is driven into isolation.

It is hard to predict whether the broad public will find a way to the appreciation of pure abstractionism, which until now has won only a limited group of admirers. It is, however, possible that such a way may be found, as it was found before when strong creative forces had wiped out tradition and opened new fields of expression. Each period is bound to a certain psychological climate, and the artist is the first to sense it and give expression to it.

Yet we are in the midst of the struggle between abstractionism and representationalism. Despite the growth of abstract

Fig. 22 Fig. 23 Fig. 24

Fig. 22. Cycladic, Female Idol, Delos, 3rd Millennium
B.C.
Fig. 23. The "Dame d' Auxerre" (Crete?), 7th century
B.C.
Fig. 24. Apollo, Olympia, 5th century B.C.
See p. 60

Fig. 25 Fig. 26

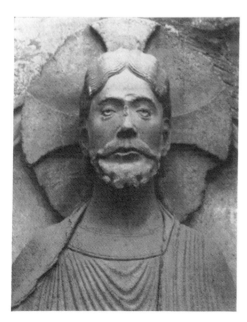

Fig. 25. The Apostle
Paulus, Rome, Catacomb
painting. *See p. 60*
Fig. 26. The Bamberg
Apocalypse (Ottonian
Art). Ca. 1000 A.D.
See p. 61
Fig. 27. Head of Christ,
Chartres, 12th century.
See pp. 17, 61

Fig. 29. Michelangelo,
The "Pietà Rondanini".
See p. 63
Fig. 30. El Greco, Toledo
in a Storm. *See p. 63*

Fig. 27

Fig. 28. Tintoretto, Christ on the Sea of Galilee. *See p. 63*

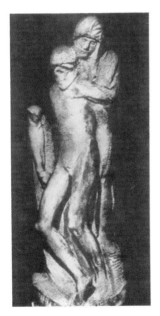

Fig. 29 Fig. 30

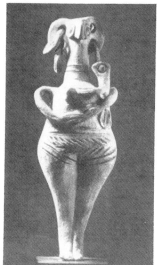

Fig. 31 Fig. 32

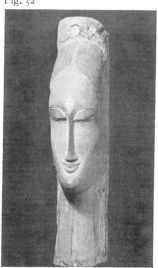

Fig. 33 Fig. 34

Fig. 35 Fig. 36

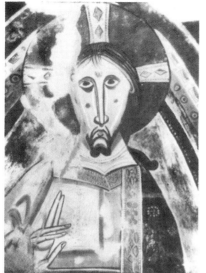

Fig. 37 Fig. 38

Fig. 39

Fig. 40. Munch, The Scream. *See p. 69*

Fig. 41. Kandinsky, Red. *See p. 67*

Fig. 42. Toby, "Rive Gauche I". *See p. 73*

Fig. 43. Redon, "Des Yeux sans
Tête ...". *See pp. 78, 86*
Fig. 44. Klee, Realm of Birds.
See pp. 72, 87

Fig. 43

Fig. 44

Fig. 45

Fig. 46

and semi-abstract art, representationalism has not yet been completely suppressed. There is no doubt, of course, that the abstract, the symbolic element, has won the first battle in this century and that, as a consequence, rules which were binding for more than five hundred years have been successfully defied. It would be a mistake, however, to think that wherever naturalistic tendencies are manifest, the older generation is at work, and that the younger generation always represents the abstract. In the winter of 1949, in Paris, an exhibition was held which caused a considerable sensation. It was made up of the work of a group of young French artists which had been gathered almost as if to prove that representationalism was not dead; for as Waldemar George wrote in the "prologue" to the exhibition, "La dominante de cette exposition est la figure humaine" ("The dominating theme of this exhibition is the human image"). This exhibition was a demonstration on the part of a young group against old revolutionary artists like Picasso, Laurens, Braque, Klee, Kandinsky, Mondrian and Brancusi—all artists who were close to 70 years of age or who had been dead for several years.

It was almost at the same time that a group of American artists, who called themselves "The Intrasubjectives", gave a demonstration in New York of exactly the opposite tendency. It was a decisive manifestation against representational art, the most radical proclamation of an unbounded subjectivism.

It would be useless to speculate as to which of these exhibitions was the stronger indication of the future. There is no turning back in history, and it would not be safe to assume

Fig. 45. Matta, The Disasters of Mysticism. *See p. 74*
Fig. 46. Gorky, Agony. *See p. 74*

that the radical turn of art away from realism were a matter of short duration. It is, however, safe to assume that the new elements will undergo change, and that new compromises with a more realistic approach to nature are possible. We should perhaps again point out that representationalism and abstraction are, in the last analysis, the product of two basic ferments of the soul. It will always depend on the psychological attitude of the artist whether he transposes reality into naturalistic form or into symbolic expression. One must also bear in mind that each movement in itself gives rise to a countermovement. When we spoke of the disquieting and alarming elements in modern life, we might have added that in such an age people begin once more to strive for protection and to open themselves to new dogmatic laws. It may be an interesting symptom that one of the founders of cubism, Robert Delauney, later described this movement as a last desperate attempt to create art by rational analysis, and one which had only served to prepare the way for a new synthesis in art. One may also recall individuals and groups like the "maîtres de la réalité", who never found it necessary to abandon their naturalistic outlook, and this at a time when abstractionism was flourishing.

In the final analysis, the work of art affects us as far as we can find ourselves in it. We recognize our own body, our movements, but also our desires and hopes, disappointments and pains. It is therefore by no means only the naturalistic which enables us to re-live as it were, in a work of art. The future of abstractionism will to a great extent depend on the growing capacity of the artists to transmit their own ideas and feelings to us, and the increasing readiness of the public to listen to the messages of these artists. The more clearly the re-

flections of our own emotions are expressed, the closer we feel to the work—and, it may be added, the stronger the painting or the sculpture will be as a work of art. This will be our main criterion in weighing the value of the work. Abstract art may be no better or no worse than representational art. A work of art will be good and important whenever it is the result of a strong manifestation of the human mind.

AFTERTHOUGHT
ON ROMANTICISM

It will be necessary in any thorough history of abstract and non-objective art to study its relations with romanticism. Twentieth century art, especially in its German-expressionist form, has occasionally been traced back to a source in the romantic movement. (S. Peter Selz: "German Expressionist painting", Berkeley, Calif. 1957.) Such research must, however, go deeper, even back to the pre-romantic "Sturm und Drang" period in Germany (ca. 1760–1790). There is an immense cultural difference between the "Geniedichtung" of that time and the spirit of contemporary art and literature; but bearing this in mind, we nonetheless find among theorists and even more among the poets, a rebellion of the mind similar to that expressed in modern revolutionary movements and manifestoes. This first romantic movement, which engaged the best German authors, was deeply influenced by the British philosopher Young, as well as by Shaftesbury and the French, J. J. Rousseau.

Thus Western Europe began to revolt against rationalism and to glorify the irrational and the un-artificial; this rebellion was based on spontaneous directness, sensibility and feeling. The leaders of the movement admonished the artists — primarily the poets, since the figurative arts did not yet take up the challenge — to shake themselves free of all rules and follow the inner impulse. The notion of the great genius, the "Genie", meant, in effect, a war against academicism, conformism and a stagnant society, against all conventions of language and artistic form. We even find the injunction to ignore the need of communicability. A turbulent wave of self-reliance and subjectivism was let loose. Young and Shaftesbury had helped to

establish the faith in genius, even treating it as "divine". In this there is a reminiscence of medieval aesthetics, but the medieval artist could only work "mediante Deo", with the help of Divine Grace, whereas for the English predecessors of Romantic aesthetics the author is the analogue of God and is himself godlike.

Schiller's formulations "sentimental and naïve" and especially, "plastic and musical", foreshadow the concept of "introvert and extravert" (C. G. Jung). Thus, in the last analysis "plastic" (or naïve) art would lead to our "objective" creations whereas "musical" (sentimental) comes nearer to what is expressed in non-figurative art. Novalis' subjectivism praises the "Einbildungskraft" (imagination) and the "inward" from which a work of art stems. Wackenroder calls it the "divine sparkle"—which is again reminiscent of Bonaventura's aesthetics and accords with the strongly religious trend of the romantic writers. Aug. W. Schlegel wants paintings to be "concerts of color" and Tieck even postulates "garish colors without any connection" (grelle Farben ohne Zusammenhang), without any object, as it were.

Yet the figurative arts had not at all reached the point of practicing what the theorists—and to a certain extent poets— preached. There is, as far as I am aware, only one passage in literature which goes so far as to describe an abstract work of figurative art. In the 1840's, the Swiss writer Gottfried Keller describes a painter, who, starting from Nature, soon relinquishes naturalness and fills the whole surface with little lines, circles, etc. An onlooker comes in and praises this endeavour highly. The artist himself stands bewildered before his "scribbling", his "spider web", his "senseless mosaic". Though working with "diligence and persistence", he has followed his "dreaming consciousness" (we would call it the *unconscious*).

His friend and critic, however, declares bluntly: "With this remarkable work you entered a new phase and began to solve a problem which may become of paramount influence on the development of German art ... You have decided to throw out everything objective". And he calls the work "a delightful abstraction". He even blames the artist for still having left some remnants of nature (trees), of "the abominable reality". They have to disappear. (Gottfried Keller, "Der Grüne Heinrich", in the chapter "Der Grillenfang".)

AFTERTHOUGHT
ON CONTEMPORARY ART

A detailed examination of contemporary artists or schools would go beyond the scope of this study, but I would like to append a few remarks on some of the discomforts and satisfactions which modern art presents to the art historian.

The power and genuineness of such painters as Pollock and Soulages and of such sculptors as Lipschitz should be beyond question. However, there are—as there have always been—many feeble, incompetent "fellow travellers"; today they contend that their mediocre abstractions have grasped and presented the "Zeitgeist". Sooner or later they will disappear, as they have always disappeared. Greater genius and human understanding and authenticity of purpose are needed to interpret and re-create the modern "soul" than can be found in frivolously smeared splotches of color or in bits of junk and rusted metal welded together at random.

Although many different directions and schools have arisen during the last half-century, it seems premature for a hand-

book of abstract art to be written. Even the word "abstract", no longer dispensable as a token of understanding, does not adequately cover the various aspects of contemporary art. "Abstraction" begins with any digression from clearly visible form and contour and is present in Roman wall paintings as well as in the work of Rembrandt and in impressionism. It is in many instances better to describe contemporary abstractionism as "non-objective", as it was officially called years ago with the opening of the first "Museum of Non-objective Art" in New York City.

Beyond our difficulties in judging and even describing modern art, we feel further uneasiness arising from even more basic, partly practical considerations. Is it still appropriate to put a frame around these abstract or non-objective paintings? Have they not a completely different meaning from that of any figurative picture? Rather, are they not very often psychological experiments, attempts to speak directly to our soul in a new language, evocations of moods which transcend frames and go beyond any limitations in space?

Do we not suffer a similar inadequacy when we face the creations of an artist such as Richard Lipold? It would be erroneous to classify them under "Applied Arts". They rather epitomize a new synthesis: these subtle and shimmering works of stainless steel and wire, this "frozen mathematics", are created out of a profound understanding of sculptural and pictorial phenomena and out of a vision that encompasses the requirements of architecture. Glowing in their splendor and seemingly weightless, they fill and at the same time create the space into which they are born. Here is the work of a genius who, in his own way, found a new medium to satisfy man's search for beauty.

List of figures

101

Fig. 24 – Apollo, Temple of Zeus, Olympia, 5th Century (ca. 460) B.C.

Fig. 25 – The Apostle Paulus, middle of 4th Century, Rome, Catacomb of Domitilla.

Fig. 26 – Illumination from the Apocalypse of St. John, Bamberg, ca. 1020 A.D.

Fig. 27 – Head of Christ, 12th Century, Chartres, Cathedral.

Fig. 28 – Tintoretto, Christ on the Sea of Galilee, Washington, National Gallery.

Fig. 29 – Michelangelo, the "Pietà Rondanini", Milan, Castello Sforzesco.

Fig. 30 – El Greco, Toledo in a Storm (detail), New York, the Metropolitan Museum of Art.

Fig. 31 – The Mother-Goddess, (goddess of fecundity carrying a child; baked clay), Cyprus, ca. 1400 B.C.

Fig. 32 – Picasso, small Female Figure (bronze), 1931–32.

Fig. 33 – Woman's Head from South Arabia, 1st Century B.C., Philadelphia, Pennsylvania Museum.

Fig. 34 – Modigliani, Female Head.

Fig. 35 – Seated Female (wood), Sudan, Africa (Ban Bara Style).

Fig. 36 – Picasso, Seated Female (bronze statuette), Pittsburgh, Collection of G. D. Thompson.

Fig. 37 – Christus Pantocrator, Mural (detail), from the Church of Esterri de Cardos, 12th Century, Barcelona, Museo d'Art.

Fig. 38 – Rouault, Head of Christ (ca. 1935).

Fig. 39 – Rouault, "Le Christ au Lac de Tibériade" (1939).

Fig. 40 – Munch, The Scream (1893), Oslo, National Gallery.

Fig. 41 – Kandinsky, Red (1924), Collection Mrs. M. Sacher, Basle.

Fig. 42 – Toby, "Rive Gauche I" (1956), Basle, Gallery Beyeler.

Fig. 43 – Redon, "... des yeux sans tête flottaient comme des mollusques," illustration from "Gustave Flaubert, La Tentation de Saint-Antoine" (published 1938), Basle, Öffentliche Kunstsammlung.

Fig. 44 – Klee, Realm of Birds, Private collection.

Fig. 45 – Matta, The Disasters of Mysticism (1942), Collection of Mr. and Mrs. James Thall Soby.

Fig. 46 – Gorky, Agony (1947), New York, Museum of Modern Art.

Sources of the Illustrations

Alinari, Florence (Figs. 1, 4, 6, 7, 9, 17); Bildarchiv Foto Marburg (2, 3, 5, 27); Gnudi, Giotto, Milan, 1958 (8, 18); W. Neuss, "Die Apokalypse des heiligen Johannes", Munster, 1931 (12); The New York Public Library, New York (15); Catalogue of the Cézanne Exhibition, Zurich, 1956 (19, 20); Photo J. Maniezzi-Antibes (21); D. H. Kahnweiler-Brassai, The Sculptures of Picasso, London, 1949 (32); H. Th. Bossert, "Altsyrien", Tubingen, 1951 (33); Catalogue of the African Negro Sculpture Exhibition, De Young Museum, San Francisco, 1948 (35); Picasso Exhibition, The Museum of Modern Art, New York, 1957 (36); Ch. Zervos, "Die Kunst Kataloniens", Vienna, 1937 (37 and the cover picture); L. Venturi, Georges Rouault, Paris, 1958 (38, 39); Galerie Beyeler, Basle (42); "Öffentliche Kunstsammlung Basel" (43); Klee-Gesellschaft, Berne (44).

A Biographical Note
by Julia Rosenthal

The art historian Erwin Rosenthal (1889–1981) was born into one of the most important bookselling dynasties in Europe and married into another. The firms of Jacques Rosenthal in Munich and Leo Olschki in Florence bestrode the trade: Rosenthal issued around one hundred catalogues between 1895 and 1940. Jacques' only son, Erwin, worked on a series of five catalogues, published in 1914, on illustrated books of the fifteenth to the nineteenth centuries. He completed his doctoral thesis on the origins of woodcut illustration in Ulm in 1912 and the same year married Margherita Olschki, Leo's daughter. His activities as a dealer in books, manuscripts, and graphics, first in Berlin where he briefly ran a graphics gallery and later in Lugano and Zurich, ran parallel with his art-historical research; his major monograph on Giotto and the intellectual development of the Middle Ages was published in Augsburg in 1924. A contribution on Poussin was included in a Festschrift for the fiftieth birthday of the writer and art historian Wilhelm Hausenstein, a close family friend, in 1932.

With the rise of National Socialism and the danger to Jews, Erwin and Margherita emigrated to America in 1941. They had spent the five previous years in Italy, France, and Switzerland and, during the war years, lived in New York and Berkeley, where the business continued. It was during this American period that Erwin's contacts with leading collectors broadened to include Lessing Rosenwald, whose medieval

miniature collection—later donated to the National Gallery of Art in Washington—he helped to build; and Igor Stravinsky, whom he advised, not least on appraising his manuscripts for the IRS. Erwin's correspondence with the redoubtable trio of Stravinsky, Gertrud Schoenberg, and Alma Mahler still exists. In November 1948, Erwin organized from the United States an auction in Zurich that included Berg's *Wozzeck*, Mahler's Ninth Symphony, *Das Lied von der Erde*, and the first version of Bruckner's Third Symphony as well as the full score of Stravinsky's *Petrouchka*.

It is striking that Erwin's last art-historical publications, dating from after his return to Europe in 1958 but published in New York, deal with modern art, when he himself was in his eighties (with the exception of his last monograph, on the illuminations of the Vergilius Romanus manuscript, published in Zurich in 1972). In America he also became a playwright—creativity and modernity being the doppelgänger touchstones of his multifaceted long life. Erwin straddled the Old and New Worlds with profound intellectual engagement, clarity, enterprise, and a myriad of qualities, distilled in the following dedication to him by the Swiss illustrator Charles Hug in his edition of Flaubert's *L'Education Sentimentale*, that recalls an evening in August 1947:

> "Il n'y a pas longtemps
> depuis les ombres—mais
> il y a toujours de la lumière qui nous guide à aimer
> devoir et travail, à respecter les valeurs humaines, à
> créer le 'vrai.'"

"It has not been long since the shadows of war—but there is always light to guide us to love duty and work, to respect human values, to create 'truth.'"

Oxford and London
June 2012